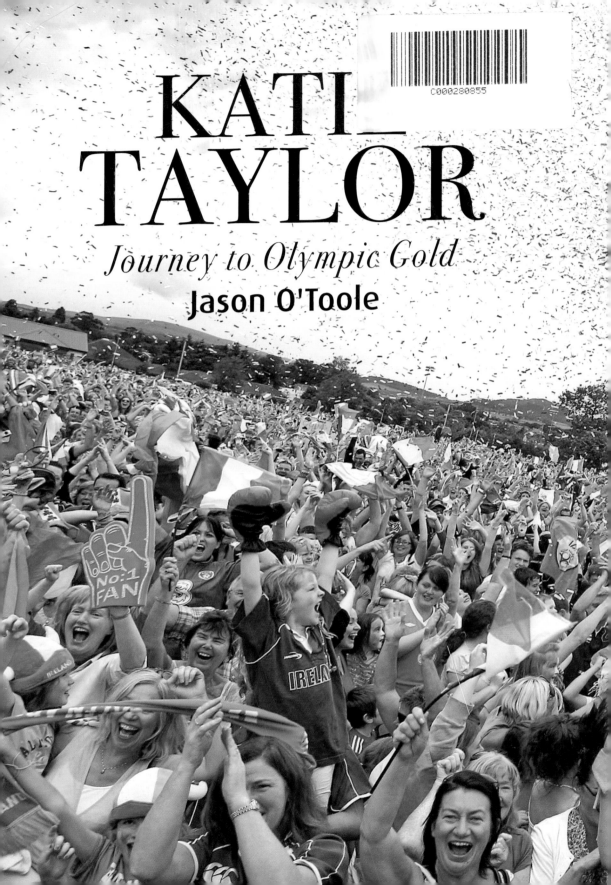

KATIE
TAYLOR

Journey to Olympic Gold

Jason O'Toole

This book was designed and produced for
Gill & Macmillan
by Teapot Press Ltd

Edited by Fiona Biggs
Designed by Tony Potter & Alyssa Peacock

Gill & Macmillan
Hume Avenue, Park West,
Dublin 12
with associated companies
throughout the world
www.gillmacmillanbooks.ie

ISBN: 978 07171 5604 7
Printed in EU

This book is typeset in Dax and Bodoni

A CIP catalogue record for this book is available from the British Library

1 3 5 4 2

THE ROUNDS WITH KATIE

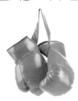

ROUND 1 – INTRODUCTION

'The Olympics is the dream and has been since I was a little girl'
Katie Taylor

NO SOONER had the bell signalled the end of the unbelievably tense final round than Katie Taylor glanced tentatively over to her corner and asked her father for reassurance. It appeared that she was mouthing the words, 'Did I do it?'

Peter Taylor nodded confidently and spoke words of encouragement, but – despite the positivity emanating from her corner – Katie's trepidation was obvious during the seemingly endless seconds before the judges' verdict confirmed that her lifelong dream had come true.

A few seconds later Katie was jumping for joy when the ring announcer began declaring the winner with those magic words: 'red corner.'

The entire country rejoiced as Katie danced joyfully around the ring after she had won what was only Ireland's ninth gold medal since the foundation of the state. She was now in the company of just six Irish gold medallists: Pat O'Callaghan, Bob Tisdall, Ronnie Delany, Michael Carruth and Michelle Smith.

It was also further history in the making because Katie was the recipient of the first ever Olympic gold medal awarded to a female boxer in the 60 kg division at the London 2012 Games. It was poetic justice that this trailblazing female boxer won that first gold medal – the Olympic Committee had been persuaded to allow women's boxing into the Games only after some of its members had been impressed by her performance in an exhibition match.

It appeared to be Katie's destiny to win an Olympic gold. From the moment she first stepped into the ring and sparred with boys, she felt at home, and soon had a strong belief that she was destined for boxing greatness. 'I'm going to go all the way to the top,' an 11-year-old Katie declared confidently during her first TV interview.

Like the majority of boxing heroes to emerge from these islands, Katie – who got her first pair of boxing gloves from Santa – grew up on a working-class estate. It was her father who inspired her to get into the ring. When she was six Katie would mock spar with Peter in the family kitchen of their modest, red-brick terraced home in Bray, County Wicklow, where they still live today. Peter – an accomplished amateur boxer in his own right – would later take Katie along to the local boxing gym, which he had founded. Peter encouraged his four children to get involved in the sport. All of them, except Sarah, took up boxing.

Peter, from Leeds, first met Katie's mother Bridget when he came to Ireland as a teenager with his family to work alongside his father at the amusement arcade on the Bray seafront.

But when his family went home, Peter was already head over heels in love with his Irish redhead and decided to stay on. The couple got married two years after first meeting at a local disco and went on to have four children (Katie is the youngest), in quick succession. 'I became a full-time mother at 17, which was a very big shock to the system,' Bridget told journalist Andrea Smith.

The Yorkshire man has a close bond with all his children, but he is particularly close to his Katie, which is clearly down to the fact that he has coached her since she took up boxing.

Peter, a former Irish champion, decided to open a local boxing club for youths in the Bray area when his own amateur boxing career was winding down. He first brought Katie to St Fergal's Boxing Club (later the Bray Boxing Club) because his babysitting duties clashed with a training session he had scheduled to coach some local youngsters.

'All the papers say she was 11; she was probably only about eight or nine,' Peter told the *Irish Daily Mail*. 'Katie was skipping around and hitting the bags. Next thing, she was sparring with all the lads. I was actually laughing about it because it was comical at the time – her in with all the young fellas.'

Katie wasn't even getting hurt in the ring; in fact, it was the other way round – she was inflicting pain on the boys. 'I was watching my dad and my brother box and I thought I'd like to have a go at it. I was sparring with a boy and I hit him in the nose and he fell and there was blood coming out of his nose,' recalls Katie.

One of her sparring partners, Ian Earls, remembers that she 'always had great speed and technical ability as a boxer', which he attributes in no small way to her father, 'because he's such a great coach'.

Conor Ahern, the Irish flyweight champion, remembers feeling the full force of Katie's punches when the two sparred in 2003. 'At first you're wondering: should I go easy here, but you realise quite quickly that you can't. Early on, she hit me and I thought, "Hello!" She punched harder than a lot of fellas I had boxed,' he told *The New York Times*.

It was the experience of sparring with these boys that would eventually give Katie an edge when she finally stepped into the ring with female counterparts.

'Obviously men are naturally stronger and faster than women, so I think it's important for every female athlete to train with men. It's only going to make you better,' Katie told *Hot Press* magazine.

Billy Walsh, the head coach for Team Ireland at London 2012, believes sparring with men gave her an edge and contributed to her uniqueness in the women's game. 'She spars with men, beats men, fights like a man,' he told *The Irish Post*. The former world champ Lennox Lewis once observed: 'She fights like a geezer – and if a geezer was in the ring with her she would knock him out.'

Peter had initially encouraged Katie to take up boxing because he thought the training and skills derived from it would benefit her main passions at the time – GAA and soccer. She went on to win 15 international caps for Ireland. Amazingly, she only stopped participating in soccer two years before the Olympics to focus on fulfilling her childhood dream of winning a gold medal.

He never once thought in those early days that she would go on to become a champion. 'I never really thought about it much because she was into so many different sports. But then every time I went up to the club, she wanted to go and I kept letting her plod along.'

But even back then Katie was clearly determined to become a top pugilist. 'I've always been really competitive, since I was a child. In every sport, I always wanted to be the best. I was always really focused as a child. I think most of the other kids were there mainly for the fun, whereas I just wanted to win each competition,' she told *Hot Press* back in 2010.

Such was her determination to reach the top that from an early age Katie would fire off missives to her idol, Irish pro boxing champion Deirdre Gogarty – who had put women's boxing on the map by stepping into the ring for what was described as one of the greatest women's bouts ever, with Christy Martin, at the MGM Grand in Las Vegas – to ask for advice.

In one of the letters, a frustrated Katie wrote to Gogarty: 'I can't see boxing for girls taking off over here in the near future. I can see why you had to go away to get fights. But maybe one day they'll even let us box in the Olympics...'

It appeared from the letters that Katie was certainly contemplating the only avenue open to female boxers back then – going pro. She told Gogarty: 'You have achieved so much already, you have done us proud (tell Christy Martin I'm getting ready for her, ha ha).'

Thankfully, turning pro was not a decision Katie would be forced to make as the amateur boxing federation in Ireland was starting slowly to come around to the idea of women boxing – thanks in no small way to Peter Taylor and others at the boxing club who relentlessly canvassed for Katie to be given her shot.

But it was certainly frustrating for Katie during her teens that – despite putting in all the effort in the gym – she wasn't getting the chance to test herself competitively. 'I always thought it was unfair that she wasn't allowed to fight. She used to always go along to the fights to support the lads,' her former sparring partner Ian Earls told *The Sun*.

Not recognising women's boxing was, Peter Taylor explains, a case of 'discrimination'. 'It was the same resistance they had when females started playing soccer. When Katie started doing well in away tournaments, they had to recognise it. Then Gary Keegan, who was in the High Performance Unit for elite athletes in boxing, came on board and wanted to put Katie on a programme. And the Irish Sports Council, in all fairness to them, included Katie in a programme even

though women's boxing wasn't yet an Olympic sport,' he told *Hot Press* in 2010.

'The Irish Sports Council have been really supportive. Everything we've asked for, the Council have backed us with, since Katie started boxing internationally. If we hadn't had their support it would've been very difficult. It was some battle before! I mean, we were paying for girls to come in and box Katie.'

Even world champion Barry McGuigan, who is now a vocal supporter of Katie and women's boxing in general, was steadfastly against the idea of it until he saw the Irish champ in action.

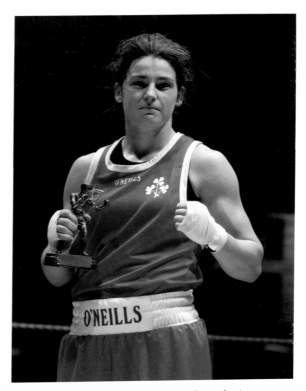

'My personal considerations were blown away. Her skill, power, speed, technique and attitude are all top class. Double left-hooks, right hands over the top; it's just extraordinary,' McGuigan wrote in the *Daily Mirror* in 2009.

Katie became a trailblazer for women's boxing in Ireland when she participated in the first sanctioned female bout held in the National Stadium in Dublin on 31 October 2001. There have been many historical firsts in Katie's distinguished boxing career to date – she is the first woman to win four successive world titles and five European titles.

It's been a long, hard journey, not just for Katie – but for women's boxing in general – to win over the most ardent detractors.

Unfortunately it appears that it's still not by any means a completed journey – with Katie having to counter blatant sexism only a year before winning the Olympic gold by threatening not to participate in the 2011 semi-finals of the world title when she, rightly, took umbrage against proposals to make skirts mandatory for female boxers. Katie was so incensed by attempts to introduce the new attire that she threatened to forfeit her shot at a title rather than participate wearing a skirt.

'They said to us, "You have to wear the skirts." I said, "Katie's not wearing that."

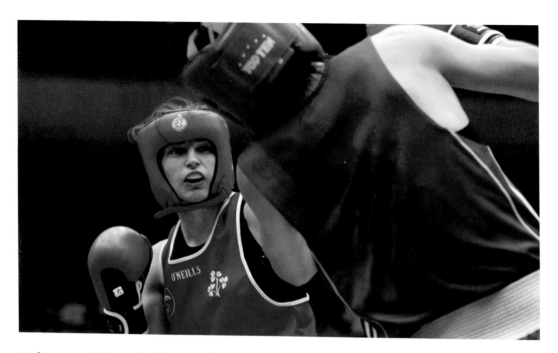

So he says, "If you don't wear them, you can't box." And I said, "Okay, so she won't box," recalled Peter, who felt that by this stage the world championship tournament needed Katie Taylor more than she needed them. Besides, self-respect was much more important for Katie. Later, the boxing authorities attempted to back down by absurdly attempting to claim that the skirts were optional.

'It's discrimination. It's men making these decisions and it's wrong. It's just marketing. We don't need the marketing. If they just let the girls box as they are, people are going to be amazed how technically good they are,' Peter told the *Irish Examiner*.

Peter was right – one of the main highlights of London 2012 was women's boxing. Katie – more than any other female boxer – helped to change opinion dramatically with her wonderful performances at the Olympics. But we shouldn't pretend that – despite everything that has been achieved so far – there isn't still deeply rooted prejudice against women boxers within the sport. If it hadn't been for Katie's stand, it's easy to imagine women boxers in skirts at London 2012.

If it wasn't hard enough being a woman in the man's world of boxing, Katie also had to endure such poor conditions in her gym – there were no toilet or shower facilities – that, according to her father, it had a negative impact on her training and her health.

Yet, despite the setbacks, Katie won the majority of her fights – and once even

chalked up an impressive 46 successive victories. There was the inevitable broken nose – in Katie's case a staggering five times when sparring with men – as she quickly rose through the ranks to become the undisputed champion of the world. But it's a measure of her fiery character that she is pragmatic about this, saying you simply have to 'get on with it' after such injuries.

'The initial punch is always really sore, but not as bad as people think. It sounds a lot worse than it is. It's a spot of blood, and there's difficulty breathing-wise, but you can always carry on. It's upsetting though, when it happens. For a girl, I think, to have a broken nose is a lot worse than a man having a broken nose. If a man has a broken nose it adds character to his face, but it's not the same for a girl...' Katie, who believes her nose is a 'bit crooked', once told a reporter.

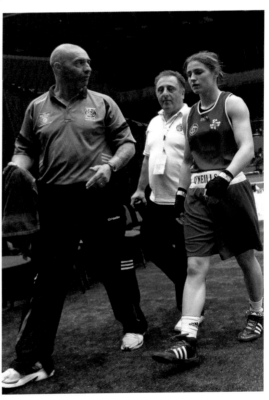

'Saying that, if I have to get a broken nose on my way to winning a world title, then so be it. I'd much prefer to have the titles and a broken nose along with it if that has to be the case.'

Initially, Katie's mother Bridget, a former boxing referee herself, was understandably apprehensive about her daughter taking up such a rough sport. 'Katie and I had a conversation early on about how things can go wrong and you can break bones and get black eyes etc. She had her nose broken a couple of times, but when she was asked about it before, she said that if you were looking back over your life, would you prefer to think, "Well, I used to be good looking", or "I was a world champion"? ' Bridget told the *Sunday Independent*.

Her father Peter admits that he finds it emotionally difficult to come to terms with his daughter getting injured. 'I think it affects me a lot. With Katie being a girl, we don't want to see her walking around with her nose like that. And it's not great for female boxing, is it, that they look beat up? If a lad has a broken nose, big deal, nobody cares... But it's different for a girl. It's a hard part of the sport,' he admitted to *Hot Press*.

Peter is adamant that he would never be afraid to throw in the towel if he felt his daughter was taking a vicious beating. 'I'd be protective too – because while she has been successful, I'd be the first to step in and stop a fight if she was getting hurt. Some coaches, mainly in the professional game, would let their fighter get killed. They wouldn't show any compassion. But I'd never see Katie get hurt,' he revealed to *The Irish Post*.

Katie has made countless sacrifices with her personal life on the road to gold. The dedication to boxing has been such that her social life is practically non-existent and she's never really had a serious relationship, despite now being 26 years old. 'Katie hasn't had a holiday in about 10 years – neither have my parents,' Katie's brother Peter said before the London Games. A good night out for Katie, her father once stated, is sitting in front of the telly with her 80-year-old grandmother.

'There's no point in having a hard week's training and then going out drinking at the weekend. And growing up as a Christian has influenced my decision as well. My parents don't drink. My elder brother and sister drink moderately. I've nothing against people drinking. There's no harm in having a sociable drink now and then, but I've just never been into that,' she told *Hot Press*.

Peter says the perception that he is somehow like one of those parents that pushes and pressurises their children in other sports like tennis or into film work couldn't be

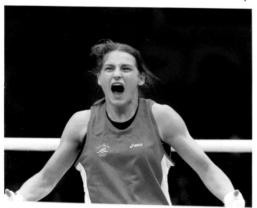

further from the truth. 'If Katie doesn't turn up in the gym at nine o'clock tomorrow morning, I'm not going to ring and say, "Katie, where are you?" I'll just go home. I'll be grand when she's finished boxing. If we went home today and Katie said she wanted to pack it in, I'd say, "That's fine." To be honest, I'm nearly looking forward to the day,' he once told Kieran Shannon of the *Irish Examiner*.

With an Olympic gold around her neck, this non-smoking teetotaller – who actually celebrated her Olympic gold medal by going to McDonald's with her father – clearly has no regrets about how boxing has turned out to be the all-consuming focus of her life.

'It's not something that I regret; that's my life and my lifestyle now. I do have to sacrifice a lot, but I'm very blessed with the life that I have been given, to be doing something that I love every day. I can't be whingeing about that!' she explained to *Hot Press*.

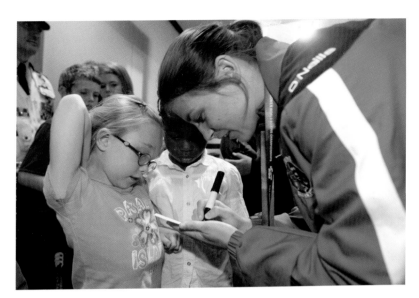

From the outside, Katie can appear be to a contradictory character: In the ring, she is a tough but elegantly expressive boxer who likes to entertain punters, sometimes by showcasing with sleek footwork to match her dazzling boxing skills, as during the Olympics. But once she steps out of the ring, Katie is shy and retiring – to such an extent that she is uncomfortable in the spotlight and doesn't like doing interviews. 'She's very quiet, but there's a real strength behind her quietness,' Bridget once explained to a journalist. 'A lot of people look at her as "Katie Taylor the boxer" – but I always say to her that's not who she is, that's what she does. Katie is very kind-hearted and would take the clothes off her back and give them to you.'

As a born-again Christian, religion plays a vital role in the psychological make-up of this Irish boxing hero. She often quotes Psalm 18 to the press, praising God in post-match press conferences for being her 'shield' and her 'strength' when she steps into the ring. She also spoke of her belief that the prayers of a nation willed her on to her Olympic gold.

Prior to every fight, Katie's pre-match ritual involves a routine of listening to Christian rock music on her iPod when she is warming up for the fight. She will then pray and recite Bible verses – particularly Psalm 18, which is affectionately known among her church's congregation as 'Katie's Psalm' – with her mother, when Bridget is tying back her daughter's hair.

Again, it would appear to be a contradiction to imagine someone with such strong religious values being involved in what many consider to be a violent sport. But this excerpt from Psalm 18 clearly sums up the motivation it instils in Katie before she steps inside the ring:

> *I pursued my enemies and overtook them;*
> *I did not turn back till they were destroyed.*
> *I crushed them so that they could not rise;*
> *they fell beneath my feet.*
> *You armed me with strength for battle:*
> *you humbled my adversaries before me.*
> *You made my enemies turn their backs in flight,*
> *and I destroyed my foes.*
> *They cried for help, but there was no one to save them —*
> *to the Lord, but he did not answer.*
> *I beat them as fine as windblown dust;*
> *I trampled them like mud in the streets.*
> *You have delivered me from the attacks of the people;*
>
> *you have made me the head of nations.*

'They are incredible verses that would be strength for every boxer,' explained her church pastor Sean Mullarkey to journalist Mark May. 'She has some of the verses hanging up in her training centre in Bray. A lot of the athletes can lose their focus or lose their peace – Katie has an amazing peace about her. All of these things [in Psalm 18] are in her head and her heart as she goes into battle and she knows she is not alone.'

But despite the violent imagery in Psalm 18, Katie insists that she doesn't go into fights with an aggressive mentality, but rather focuses on the technical side of boxing to win.

'I think if you're angry, that's when you make stupid mistakes. If you're too aggressive, that's when you get caught out. It is a thinking match in the ring all the time – you have to think about everything you do. The sport is highly technical.

I'm always really focused in the ring, so anger isn't a problem for me,' she explained. 'There's been a few times when I've been boxing that my opponents have tried to make me angry, but I've never succumbed to it. I just stayed calm and kept going with my boxing,' she once told journalist Adrienne Murphy.

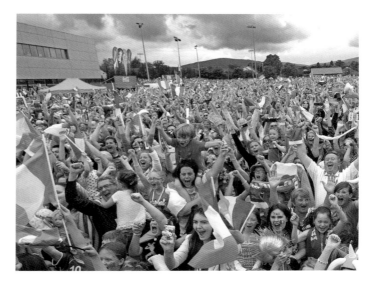

It was Katie's mother who first found God and then brought the rest of the family with her. Bridget – who says God came into her life because she was 'a bit of a mad thing as a teenager and went off the rails a bit', and she then discovered a 'better way of life through the church' – believes that God is in her daughter's corner. 'We believe that everything that Katie has achieved comes from God, and what she's doing is a gift from him. I always pray with her before every fight for protection and strength,' she said in 2011 to journalist Andrea Smith.

Like her mother, Katie believes that God called her into the ring. 'I just feel that this is exactly what he wants me to do, and I just want to honour him in everything I do and live a really great life for him... I think boxing is what I was born to do. Everyone has gifts and talents, and that's what God wants you to do. I think it puts a big smile on God's face when you're doing what you were born to do,' she told *Hot Press*.

After a victory, Katie will normally look up to the heavens in thanks. 'God is my psychologist, the Bible is my sports psychology manual,' she once told *The Irish Post*. She added later to another paper, 'And my Dad is probably the best sport psychologist in the world.'

ABOUT THIS BOOK

This pictorial book – with accompanying explanatory text for each photograph – charts the highlights of Katie's magnificent career to date. It starts with how Katie made boxing history by participating in the first officially sanctioned women's bout held in this country. She was only 15 years old at the time. Fast-forward a little under

four years and Katie was making history again by becoming the first Irishwoman to win a European title. Katie put herself into the history books yet again by becoming the first female boxer to win four successive world titles, as well as winning a total of five European amateur championships and four European Union amateur titles. Of course, there is also another first – the first Olympic gold medal awarded to a female boxer in the 60 kg category.

All the glorious victories are chronicled in this book to celebrate the career of Ireland's most successful contemporary athlete, perhaps even of all time. What one quickly learns from glancing through this book is that Katie is the next best thing to infallible – with only six defeats recorded in her career. It's an astonishing feat when one considers that she had recorded over a hundred victories by the end of 2011.

And many of these defeats have been suspect, to say the very least. Half of her defeats were against Turkish boxer Gülsüm Tatar in Turkey, with very dubious results – Katie even knocked her down a staggering six times in one of these fights but yet the decision still went against her. 'We knew we were going to get robbed, but we went over to get a contest,' Peter said. Yet Katie beat the same opponent five times on neutral territory. Such suspect defeats annoy her because it is recorded as 'a loss on my boxing card'.

Even when Katie lost to the Russian Sofya Ochigava – whom the Irish champ went on to beat in the Olympic final – in the semi-finals at the Ústí nad Labem Grand Prix in the Czech Republic in 2010, it later emerged that two of five judges were Russian...making it appear to be yet another hometown decision like the ones she faced in Turkey.

Perhaps the most controversial defeat was when she lost in the final of the Strandja Multi-Nations in Bulgaria to Denica Eliseeva – an opponent Katie had comprehensively beaten 16–1 in the final of the European Union title fight in 2010. Everyone could see the fight was fixed – with 13 judges from the Bulgarian Federation later being suspended – and an embarrassed Eliseeva even apologising to Katie for the sham. 'It's very discouraging when you're depending on judges being honest and fair. You wonder, how can you get away with that?' Katie stated afterwards.

On neutral territory, the nearest anyone came to pushing Katie to the limit was Quanitta 'Queen' Underwood in the semi-final of the World Championship in 2010. Katie, who was feeling weak going into the fight, had taken a large 10–2 lead after the first two rounds, but the US champ came out brawling like a caged animal in the final two rounds to look like she was pulling ahead. But, somehow, Katie – after hearing her father screaming the tight score to his daughter with only 30 seconds

left ticking on the clock – found the inner strength to go on to win 18–16, in what was certainly one of the closest and toughest bouts of her career.

'The fights are the best bit. Dad always tells me, the hard bit is training; the fight is the easy bit. It's a great feeling when things are going smoothly in the ring. Or even when you're in a tough fight; that's something you dream of as well, having to dig deep and coming out on top. Or even before a fight and the adrenalin is pumping. There's nothing like it,' she once told the *Irish Examiner*.

'I don't get complacent because I know if you slack off, you're going to be found out. This is international boxing and every fight is a tough fight. I'm winning these competitions because I'm boxing well in these competitions; it's not like I'm just turning up on the day and boxing.'

What about the future? At just 26, Katie could even surpass her own childhood dream of winning that single Olympic gold – if she decides to continue with amateur boxing and looks towards Rio 2016. The future may be uncertain, with much speculation about her next career move. Will she stay in the amateur set-up? Will she turn pro? Will she go back to soccer? But whatever path Katie goes down, one thing is certain – we haven't heard the last of this living legend.

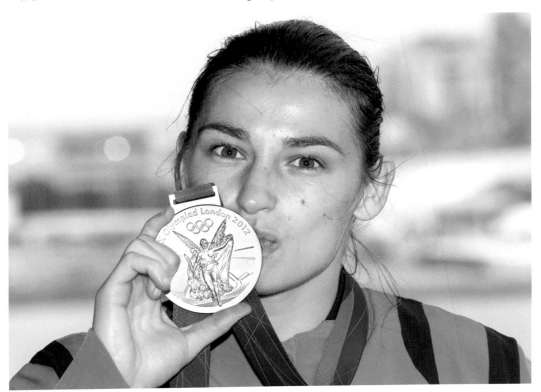

ROUND 2 – KATIE GETS STARTED

Katie Taylor struck a giant blow for women's boxing when she participated in the first officially sanctioned women's bout ever held in this country on 31 October 2001. Katie, who had waited three years for her first official contest, by this stage had already shown her pedigree by going unbeaten in a string of unofficial exhibition matches against boys at St Fergal's Boxing Club. On the historic night, the then 15-year-old teenager fought 16-year-old Belfast pugilist Alanna Audley (now Murphy) at the National Boxing Stadium in the first of three female matches contested on a 16-bout amateur card. The future Olympic gold medallist won the fiery three-round bout with a comprehensive victory of 23–12.

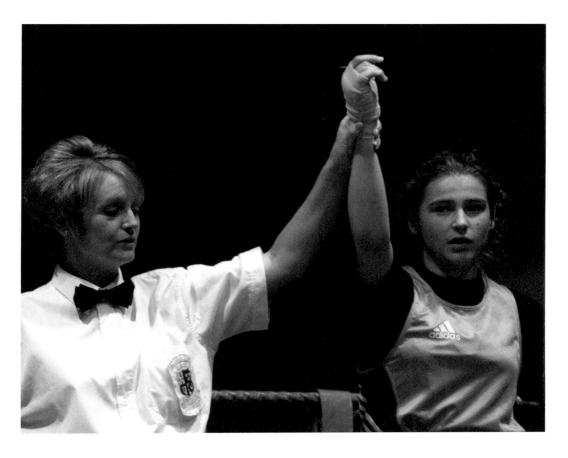

'It was a wonderful night. Katie's victory was great, but what was truly satisfying was that all these veterans of the Irish boxing world were remarking that her fight had been the highlight of the entire night,' remarked the senior coach at St Fergal's, Al Morris, who had canvassed the Irish Amateur Boxing Association (IABA) to give official recognition to female boxing. It was described as a 'momentous day for Irish boxing' by IABA Director of Boxing, Dominic O'Rourke.

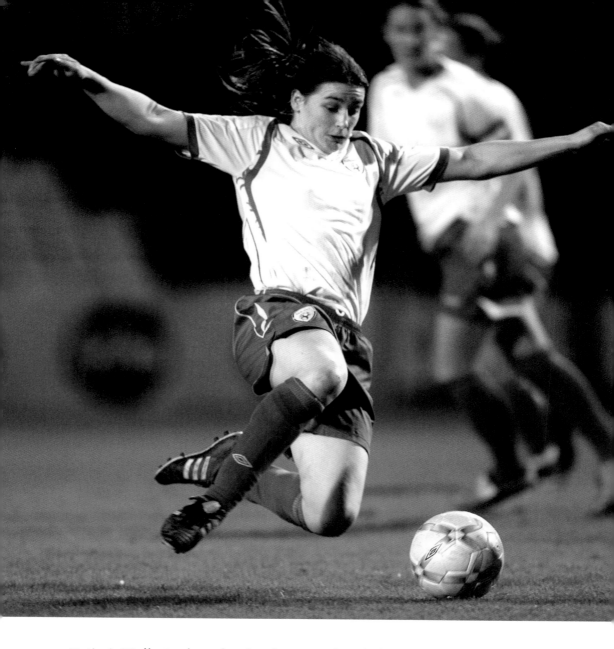

Katie initially took up boxing because her father thought it would help improve her fitness and skills for her main passion back then – soccer. Katie, who also played GAA, first ran out onto a soccer pitch at the age of nine for local side St Fergal's. She went on to win 15 international caps for Ireland and played for top side Peamount United – a team that would eventually go on to play in the women's champions league and become the first Irish league side to reach the knockout stage of a European competition.

Katie – pictured playing a Women's World Cup qualifying tie in April 2006 – only stopped playing soccer two years before the London Games. She was once described as an 'excellent...very competitive attacking midfielder' by her former international coach, Noel King, the former manager of Shamrock Rovers.

Like Roy Keane, Katie was a leader on the pitch, which was clearly demonstrated in one of the last matches for which she donned the green jersey: King recalls Katie scoring a 'cracking' goal for Ireland to take the lead against Italy before she was 'unfairly' sent off for two yellow cards. Her absence was such a blow for Ireland that the Azzurre went on to win 4–1. After winning gold at the Olympics, it was speculated that Katie would take up a professional contract with Arsenal! She was such a good player that – despite being absent from the game since early 2010 – Noel King stated that she would be 'welcomed back with open arms'.

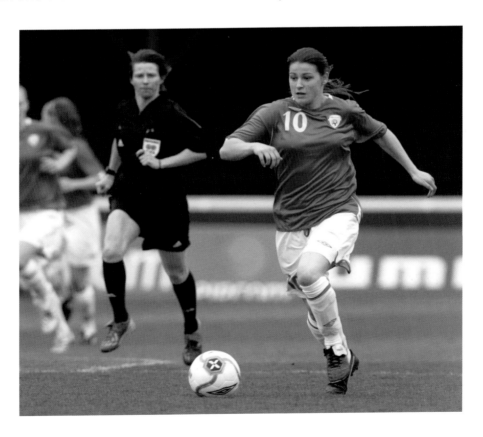

ROUND 3 – UNSTOPPABLE KATIE

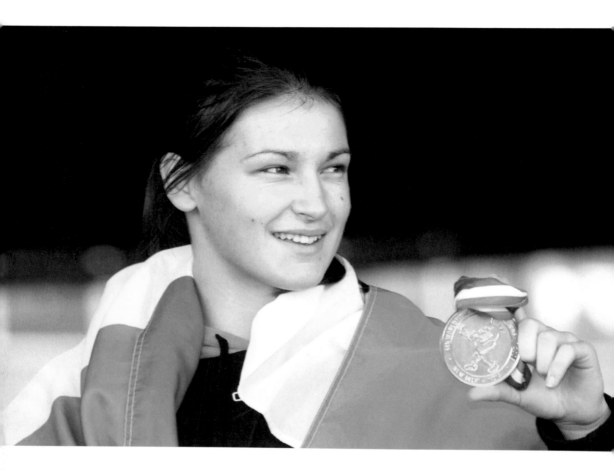

Shortly after sitting her Leaving Cert, 18-year-old Katie accomplished yet another first for Irish boxing when she became the first Irishwoman to win a gold medal at the Senior European Championship in Norway in 2005. She stopped her opponent, Eva Wahlström of Finland, in the third round of the 60 kg lightweight class. The following year, Katie retained the gold medal when the championship was held in Warsaw, Poland, by overcoming the

reigning world champion, Russian Tatiana Chalaya. Katie – pictured posing
with her medal alongside her father Pete and mother Bridget at Dublin
Airport during the celebratory homecoming – also won the tournament's
best boxer award at the 2006 competition. She went on to win gold a
further three times at the European Championship.

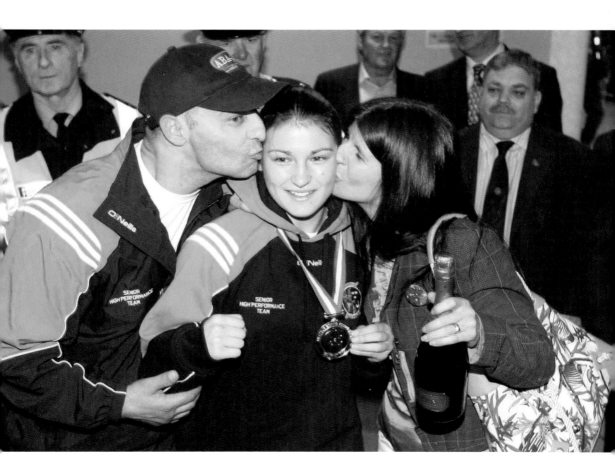

In 2007, Katie, then 21, already had a reputation for being unstoppable in the ring and had won her third successive European Championship title in Denmark. She is pictured here in her semi-final bout with Yana Zavyalova from Ukraine, on 18 October 2007. By this stage Katie was already ranked number one in the world and she comfortably won the three rounds – 4–0/6–1/11–4.

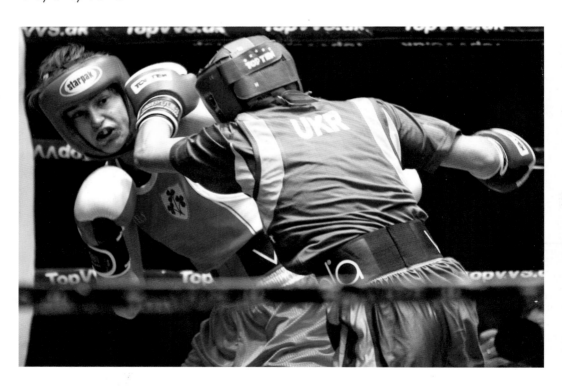

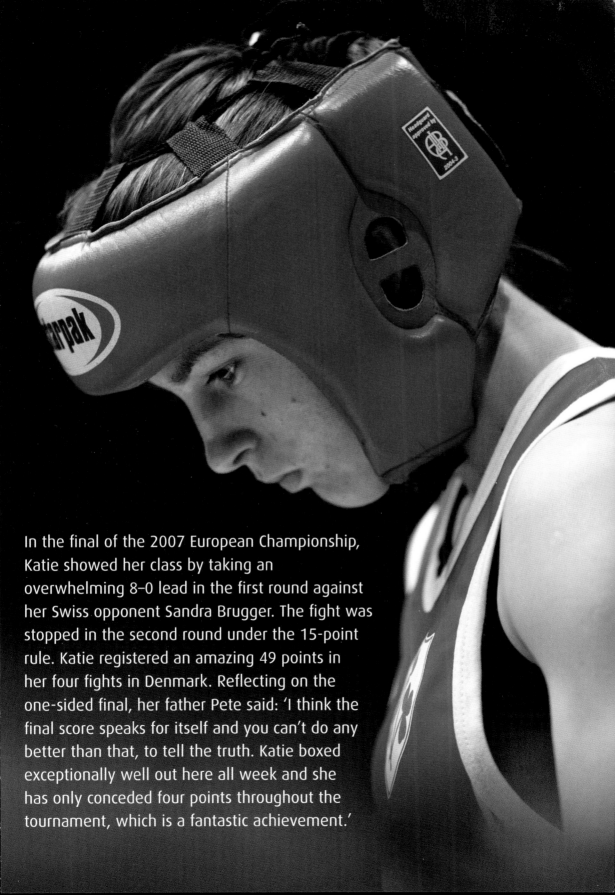

In the final of the 2007 European Championship, Katie showed her class by taking an overwhelming 8–0 lead in the first round against her Swiss opponent Sandra Brugger. The fight was stopped in the second round under the 15-point rule. Katie registered an amazing 49 points in her four fights in Denmark. Reflecting on the one-sided final, her father Pete said: 'I think the final score speaks for itself and you can't do any better than that, to tell the truth. Katie boxed exceptionally well out here all week and she has only conceded four points throughout the tournament, which is a fantastic achievement.'

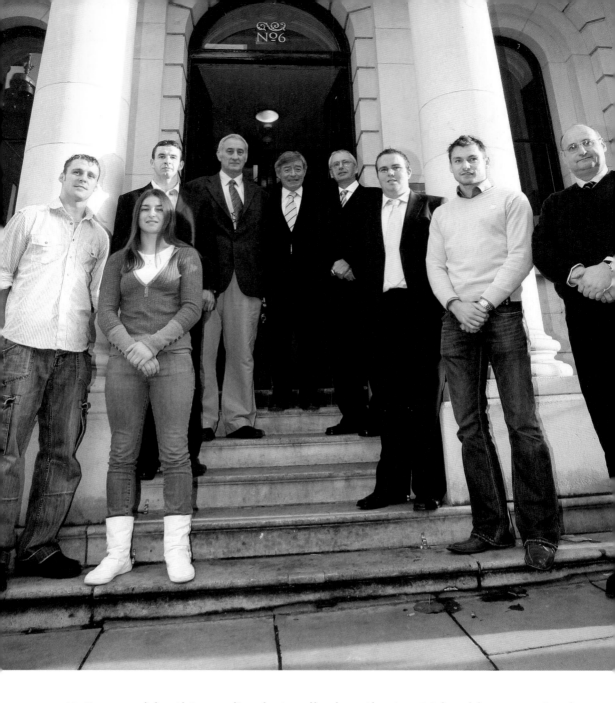

Katie posed for this media photocall when the top Irish athletes received their bonuses in 2007 from the Irish Sports Council. Also in the photo are Roy Sheehan, Eoin Rheinisch, Ossie Kilkenny, the late Séamus Brennan (then Minister for Arts, Sport and Tourism), John Treacy, Shane Lowry, David Gillick and Philip Murphy.

Two months after winning her third successive gold medal for Ireland at the European Championship, Katie was one of 10 athletes presented with the 2007 Texaco Sportstars award. The event was marking its fiftieth anniversary that year. Speaking at the event in UCD, Taoiseach Bertie Ahern told the audience: 'Katie made history in 2005, when she became the first Irishwoman to win a gold medal at the Senior European Championships. Katie is also the first female boxer ever to receive an award in the history of this event.'

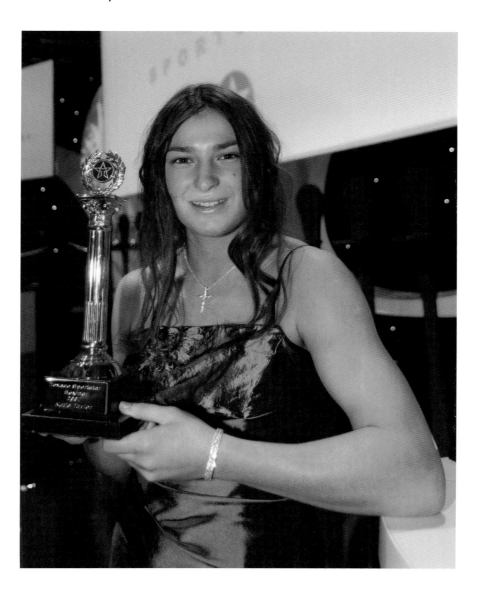

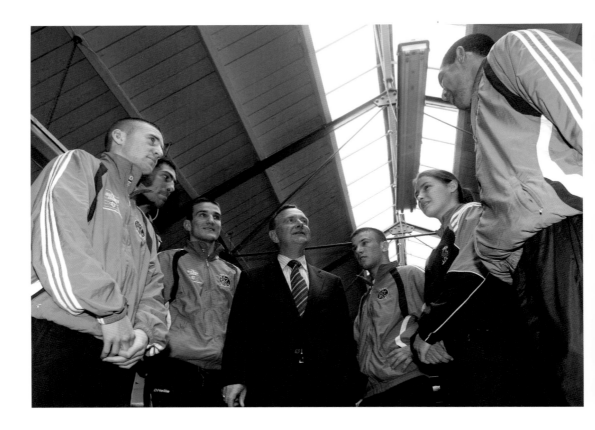

Katie was upset that she couldn't compete in Beijing 2008 after the Olympic Committee ignored efforts to have women's boxing introduced as an official sport. 'I was very disappointed when it was turned down for 2008,' she admitted. 'It is every athlete's dream to represent their country at the Olympics and I'm no different, and all we want is the same opportunity as other athletes. First we were told that women's boxing would be included for Beijing, and then we were told "no", which was devastating.

'Men are allowed to box, so women should be allowed to as well. It is a very tough sport, but I love the training. The best thing is winning the gold medal, standing up on the podium and hearing your national anthem. There is nothing like it.'

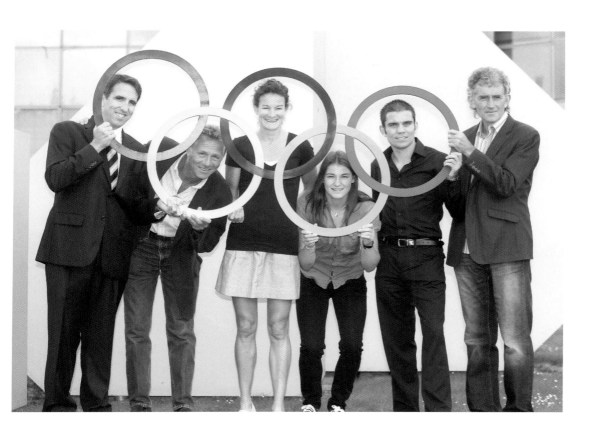

It was a dream that would finally came true for Katie.

It was a clear demonstration of Katie's growing popularity that – despite not being part of the Olympic team in 2008 – she was invited to attend media events to promote the Games that year. Katie is pictured (opposite) with the men's 2008 Olympic boxing team (left to right: Paddy Barnes, Kenneth Egan, Joe Joyce, John Joe Nevin, and the late Darren Sutherland) when they met the Minister for Arts, Sport and Tourism, Martin Cullen, shortly before heading over to China. Katie was also a panellist on RTÉ's coverage of the Olympics. She is pictured at the broadcaster's launch of their scheduled TV coverage for Beijing with Gary O'Toole, Eamonn Coghlan, Sonia O'Sullivan, Bernard Dunne and Jerry Kiernan.

Katie claimed her second consecutive World Cup gold medal in Hungary after beating Eva Wahlström of Finland once again. Three years previously, Katie had beaten Wahlström to make history by becoming the first Irishwoman to win gold at the Senior European Championship.

Two months after winning her second successive European title, Katie arrived in China's Ningbo City for the November 2008 AIBA Women's World Boxing Championship as the bookies' favourite to win her second world title at the event. This picture was taken shortly before her quarter-final bout.

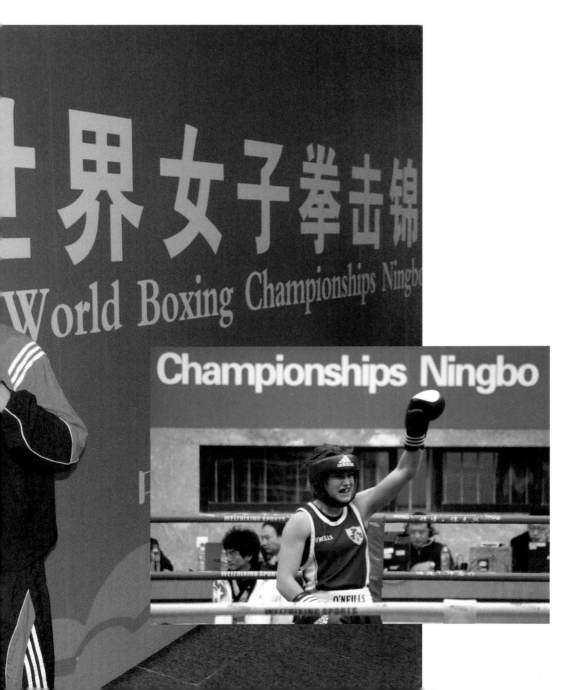

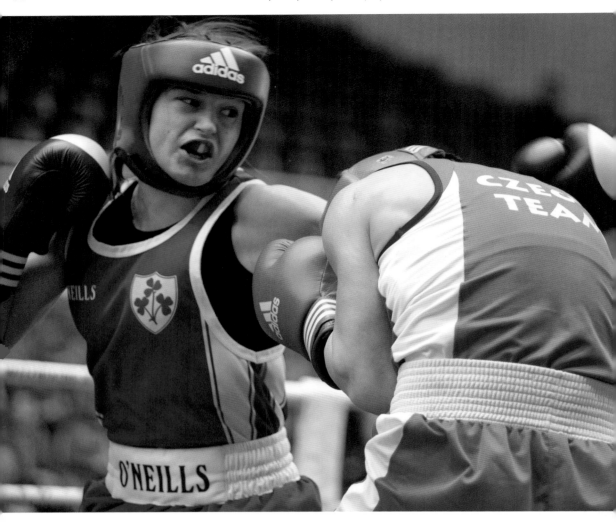

Katie in action against the Czech Republic's Danusa Dilofova for a place in the quarter-finals of the AIBA Women's World Boxing Championship in Ningbo City, November 2008. Katie was aiming to win her second consecutive world title in China, but this bout was on a knife edge: Katie went up 3–0 in the second round, but then quickly conceded two points after receiving a warning for holding. Dilofova then drew level, but Katie managed to clinch a well-deserved 4–3 victory.

Katie captured as she listens intently to her father Pete's advice before winning the semi-final bout of the 2008 AIBA Women's World Championship against Russian champion Ayzanat Gadzhiyeva. Pete admitted that he often struggles to watch his daughter battle it out in the ring. 'Separating my roles [as father and coach] is the most difficult thing for me now. It's tough to watch your daughter in a boxing ring and it's very nerve-wracking,' he told the press only weeks before the London Olympics.

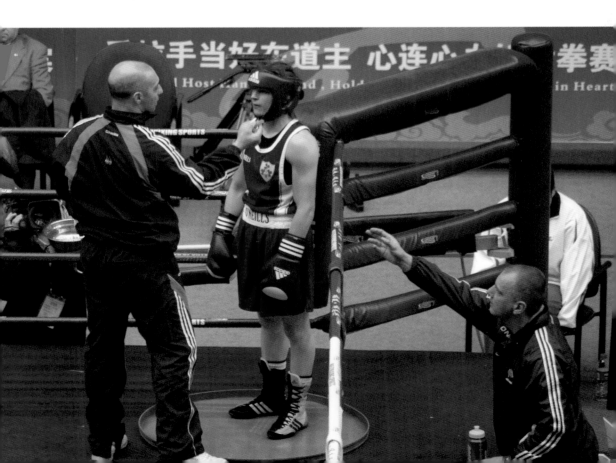

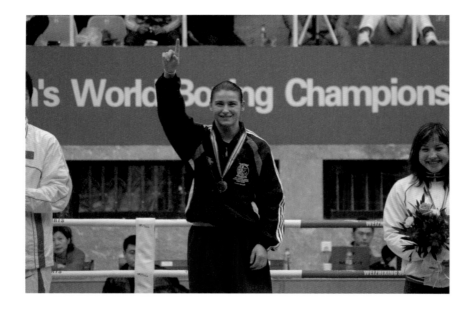

Celebrating her gold medal... Katie marked her one hundredth boxing match by beating her Chinese opponent Cheng Dong to win her second consecutive world title at the 2008 AIBA Women's World Championship. Katie won the bout by a considerable margin of 13–2, making the hometown fighter the only one of six Chinese boxers who had reached a final that year but failed to win a gold medal. The two boxers were destined to meet again in the 2010 final – with a similar result in Katie's favour.

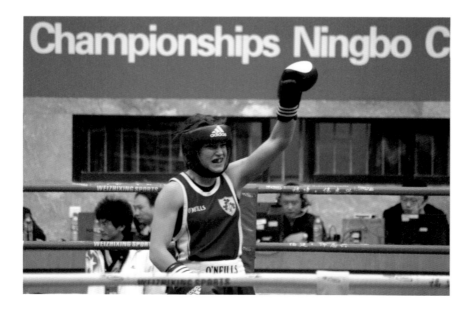

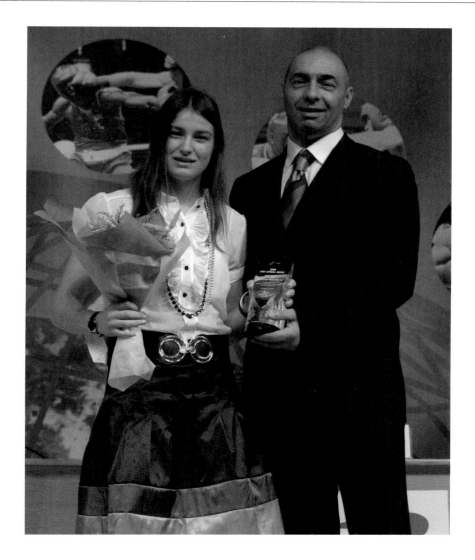

A couple of weeks after winning gold in China at the 2008 AIBA Women's World Championship, Katie travelled to Moscow with her father to be crowned the AIBA Female Boxer of the Year at an award ceremony. But all the success was coming at a heavy price. Peter once spoke openly about the sacrifices his daughter was making to pursue her dream of Olympic gold: 'She doesn't have a social life; you can't burn the candle at both ends. If you want to compete at the top then you have got to make sacrifices. Boxing is what she loves doing. She doesn't have time for a relationship and Katie is happy doing what she's doing at the moment...as long as she's happy and healthy, that's the main thing for me.'

ROUND 4 – RTÉ RECOGNITION

As undisputed world champion, it was only to be expected that Katie would be short-listed for the RTÉ Sports Awards, held in association with the Irish Sports Council, in December 2008. Shockingly – like the previous year – she was overlooked by RTÉ. Further highlighting the snub against Katie was the award to Mick McCarthy while he was the manager of the Irish soccer team and not technically a sportsperson *per se*. Katie also failed to win the award in 2010 and 2011 – despite, at that stage, clearly being Ireland's undisputed greatest athlete in living memory, or, as some argue, of all time. Another amazing statistic is that the only female winner of this award to date is Sonia O'Sullivan, all the way back in 2000. But it will certainly be hard to justify ignoring Katie yet again at the event in December 2012. She is pictured here at the 2008 ceremony with her father Pete, elder sister Sarah and mother Bridget.

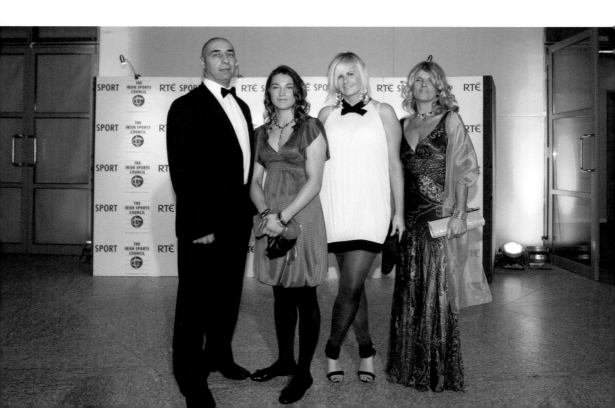

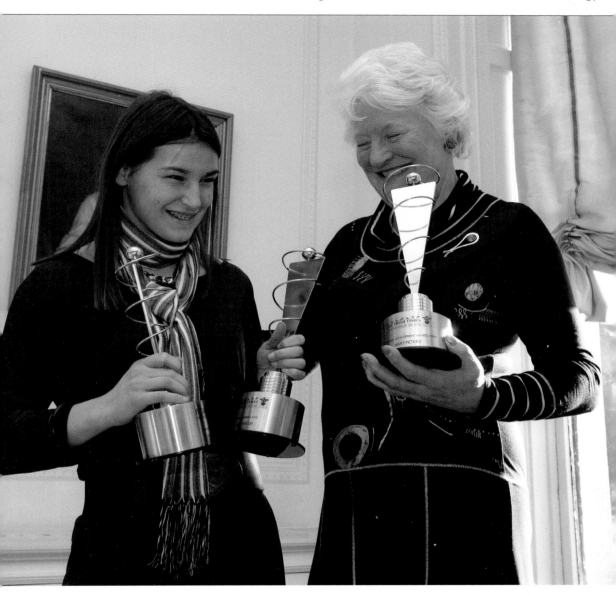

Katie was awarded the Irish Times/Irish Sports Council Sportswoman of the Year Award in 2009. The newspaper had also named her their sportswoman of the year in 2008. She is pictured here with British Olympic gold medallist Dame Mary Peters, who was presented with a Lifetime Achievement Award.

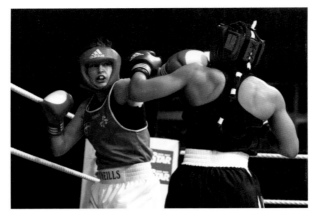

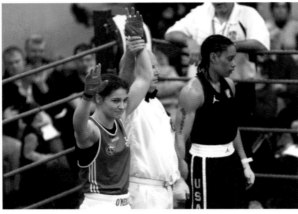

Katie was awarded this win by way of stoppage over Quanitta 'Queen' Underwood during the Ireland Vs USA Senior Boxing International match in 2009. But it was a much tougher fight when the two battled it out the following year in the semi-final of the World Championship. Katie took a comfortable lead of 10-2 during the first two rounds, only to be astonished when Underwood came out brawling like a untamed street fighter and dramatically pulled the bout back to a draw at 16-16 in the final round. The intensity was such that the Irish champ went down on the canvas after slipping. But, like her counterpart, Katie overcame her shock and dug deep to land some vital shots in the dying moments to etch out an 18-16 victory. It was one of Katie's closest ever bouts. Sports punters had tipped Underwood as Katie's biggest threat for Olympic gold in London 2012, but the American failed to live up to the hype by losing out to Liverpudlian Natasha Jonas.

Katie is pictured with the Irish team for the Ireland Vs USA Senior Boxing International event in March 2009. The team included team captain Roy Sheehan, Mullingar man John Joe Joyce – who went on to do Ireland proud by winning silver at the London Games – Ruairi Dalton and Eric Donovan, a European bronze medallist.

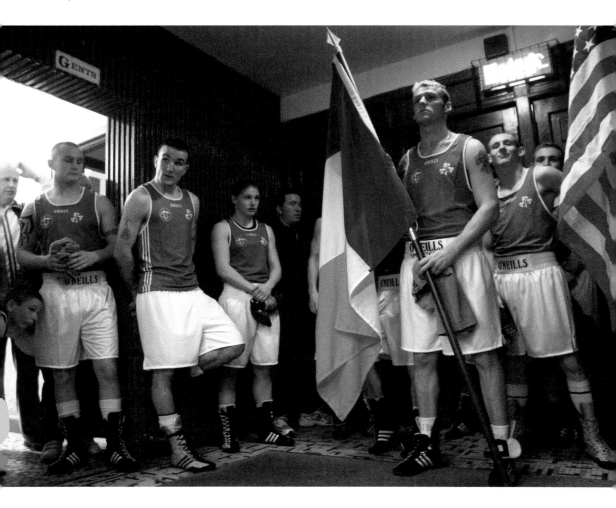

ROUND 5 – HUNKY DORY

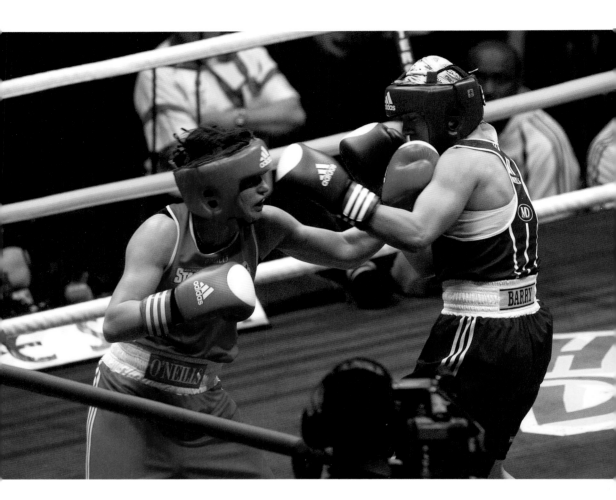

Katie fought as one of the amateur undercards – alongside Olympic medal winners Paddy Barnes and Kenneth Egan – in Bernard Dunne's title fight in the 02 arena on 21 March 2009. According to press reports, the IABA was initially opposed to Katie fighting on pro-am bills, but an agreement was reached for her to fight regularly at such events as it was feared that she would turn professional if she didn't get her way.

The event – called the Hunky Dorys Fight Night after its sponsors – was the first world boxing championship title fight in Dublin in over 13 years. It was arguably the biggest event in the Irish boxing scene since world champion Barry McGuigan fought Danilo Cabrera at the RDS in 1986. Remarkably, it was also the first time that an Irish mainstream audience had their first glimpse of Katie in action on TV. Despite being world and European champion for several years at this stage, it was the first time RTÉ had aired one of her fights. Another first – as sports commentator Jimmy Magee remarked that night – was that it had been 61 years since Ireland had last won a world boxing title and a rugby grand slam on the same day.

'As I said on commentary that night, she is the most spoken-about Irishwoman – everybody was talking about her, but nobody had ever seen her [in a televised fight], and here she was on what transpired to be a momentous day in Irish sporting history in front of this big audience on live television,' Jimmy Magee recalls.

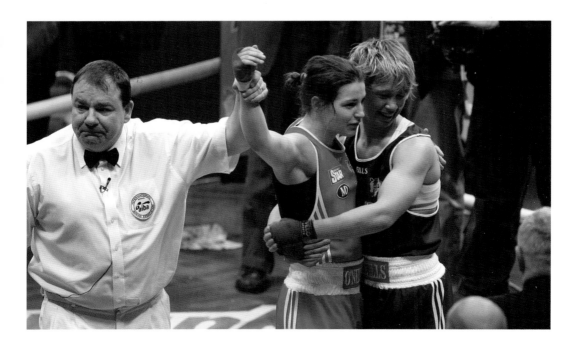

'Whatever reputation she had before she now had a "live" reputation, and people now knew who she was and how talented she really was. She is just unbeatable. In my opinion she is Ireland's greatest contemporary sports person.'

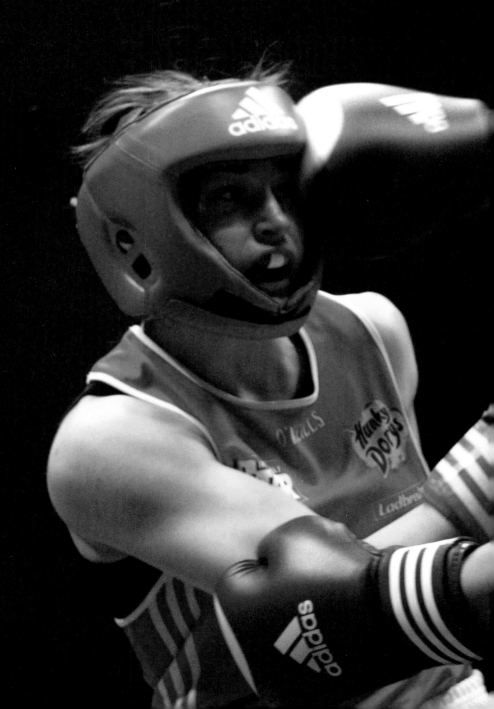

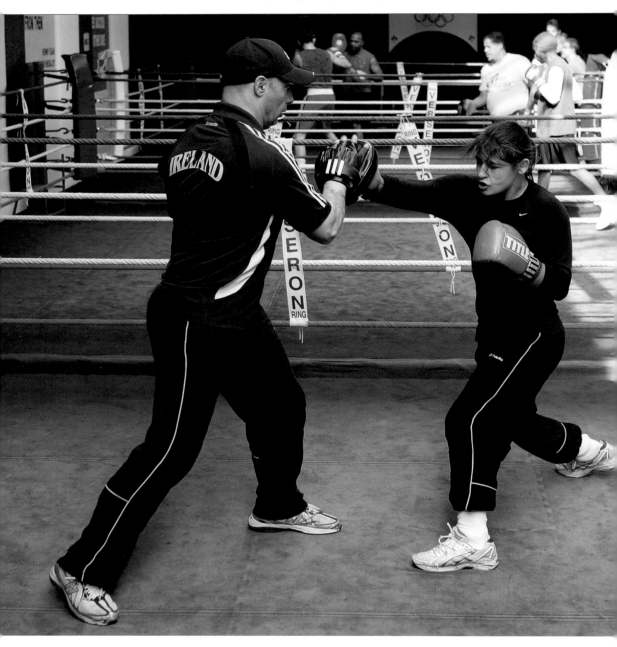

Katie sparring with her father for the Hunky Dorys Fight Night Media Workout, the day before St Patrick's Day in 2009.

ROUND 6 – THE ROAD TO GOLD

After the disappointment of not being able to compete at Beijing 2008, an elated Katie speaks to the press after learning in the summer of 2009 that she would finally get her shot at the gold medal in London 2012. The Olympic Committee had finally allowed women's boxing into the tournament. It had been a lifelong dream for Katie to compete at the Olympics – something she had first spoken about during an interview with RTÉ when she was just 11 years old and had confidently declared that she would one day win a gold medal.

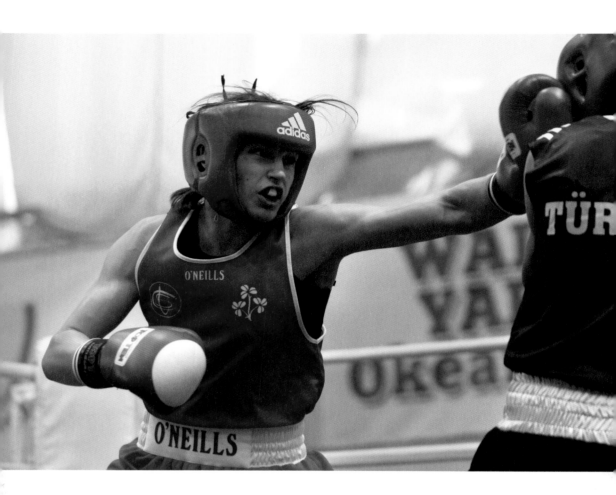

After beating pan-American champion Caroline Barry on the undercard of Bernard Dunne's world fight at the 02 arena in 2009, Katie then focused her attention on retaining the European Championship title – for an impressive fourth time in a row. Going into the final in Ukraine, Katie was on fire and had yet to concede a point. She stopped her Swedish opponent Kosovare Buzuku in the first round of the quarter-final; she then won her

semi-final against Denica Eliseeva of Bulgaria 8–0. She easily softened the roar of Meryam Zeybek Aslan (Aslan, a common Turkish name, means 'lion') by annihilating her 11–0, setting a new, impressive standard for international amateur boxing by not conceding a single point throughout the entire tournament.

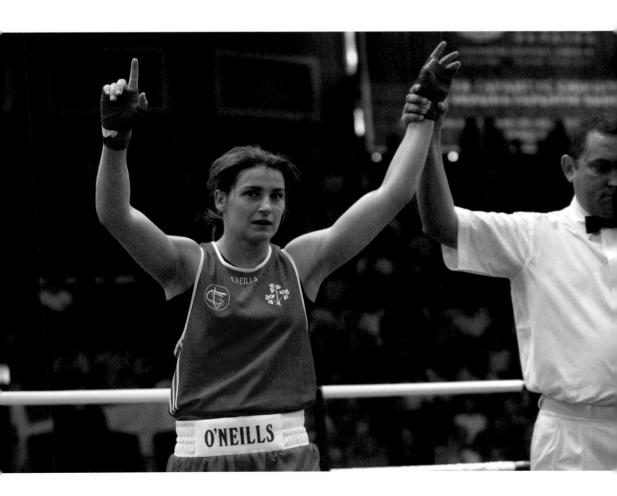

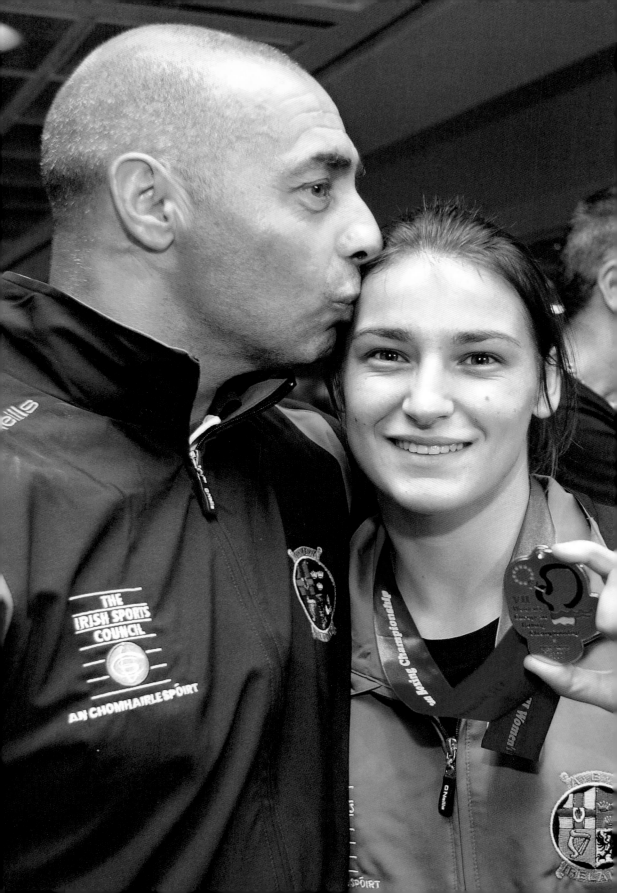

Coach Peter Taylor affectionately kisses his beloved daughter on the forehead as she proudly shows off her fourth consecutive gold medal at the European Championship in 2009.

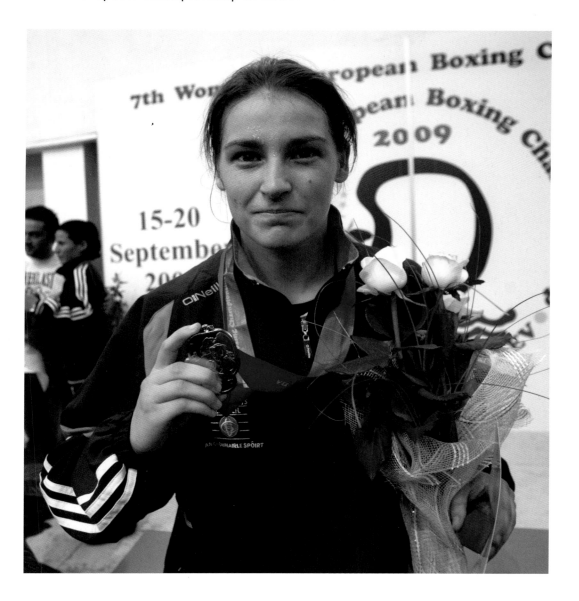

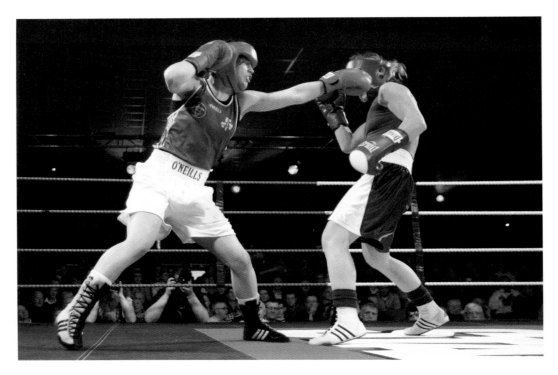

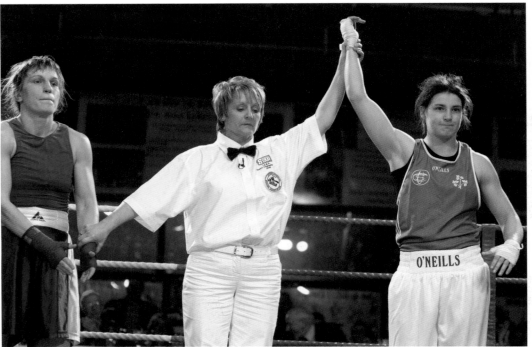

The reigning world and European champion Katie Taylor pictured at the Irish Elite Championship final at the National Stadium on 5 March 2010, after beating the Ukrainian boxer Julia Tsyplakova 19–4. The two women also fought the previous night, with Katie winning 10–2 at Elite's first senior championship for women.

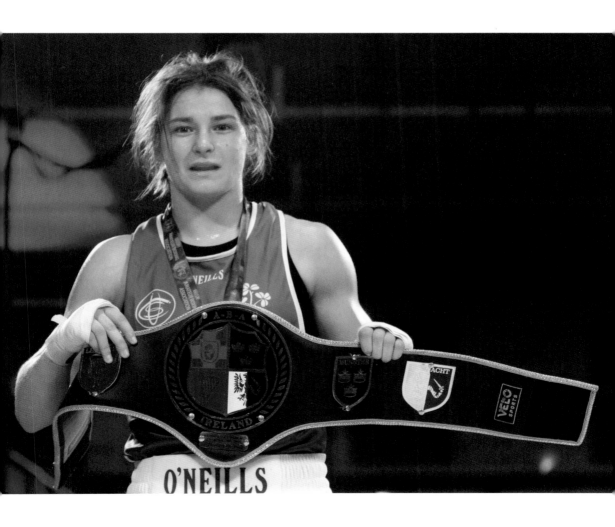

Katie proudly displays her trophy after beating Julia Tsyplakova in the 2010 Irish Elite Senior Championship final on 6 March 2010. However, the Wicklow boxer faced heartbreak later that same month when her sensational unbeaten run of 42 bouts, which stretched back to 13 May 2007, came to a halt after a shock 8–1 defeat over two four-minute rounds to former world champion Sofya Ochigava of Russia in the semi-finals at the Ústí nad Labem Grand Prix in the Czech Republic. It was later reported that at least two of the five ringside judges for the fight were Russians. The last time Katie had lost a fight was to Gülsüm Tatar of Turkey in the Ahmet Comert Cup final in Istanbul in May 2007. 'It's very disappointing when you lose, obviously, but it's all part and parcel of it. I think you learn more from your losses than your wins,' Katie once told Andrea Smith in an interview in *RSVP* magazine.

Katie, who has beaten her Russian counterpart three times now, would later have the proverbial last laugh over Ochigava when the two later met in the finals of the World Championship and the London Olympics.

The Irish team took time out from the preparations for the AIBA Women's 2010 World Championship in Barbados by posing for a photo on Maxwell Beach in Christ Church. Katie is pictured with her father Peter, who was the team's head coach, Alanna Murphy, Sinead Kavanagh, Ceire Smith and Zaur Antia, the team's technical coach, known as the quiet man in Katie's corner. Zaur, from Georgia, first met Katie when he walked into the Bray gym in 2003. 'Very early I said about Katie, "She will be a legend". This was before she even became world champion,' Zaur recalls.

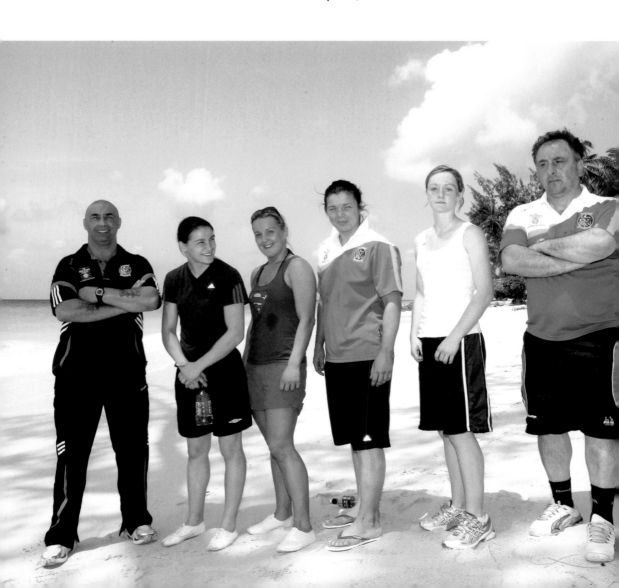

Katie preparing for the AIBA Women's World Championship in Barbados in 2010. Coming off the back of a shock defeat to the Russian Sofya Ochigava – her first setback in over 40 fights in three years – Katie was more determined than ever to retain her title for a third consecutive year.

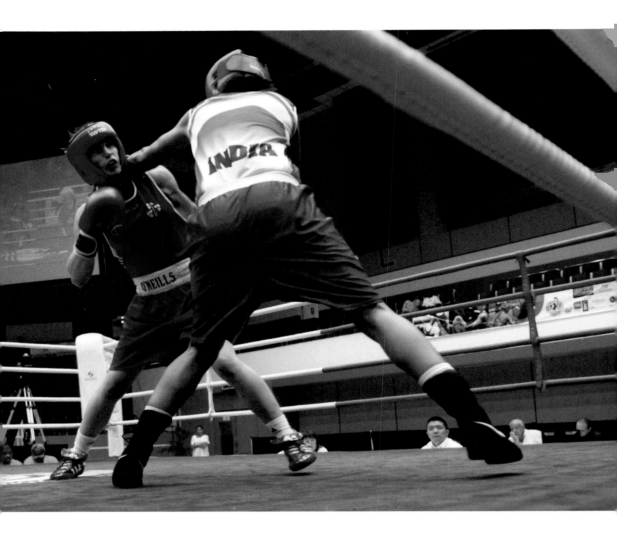

Dressed in blue, Katie pictured in action against Neetu of India in the preliminaries of the AIBA Women's World Boxing Championship 2010. Despite winning comfortably with a 12–2 score line, a modest Katie later insisted that the fight wasn't as easy for her as it may have appeared to the spectators. 'I wouldn't say it was easy. She was very awkward. The first bout of the tournament is always the hardest, just to get into the tournament. We have come over with four boxers. It makes it easier when I have someone to talk to and it's great that they could come along. Women's boxing is coming on really well in Ireland,' she said afterwards.

A relaxed Katie leaves the arena with her father Peter Taylor and technical coach Zaur Antia after her comprehensive victory of 12–2 in a preliminary bout with Neetu of India at the AIBA Women's World Boxing Championship 2010.

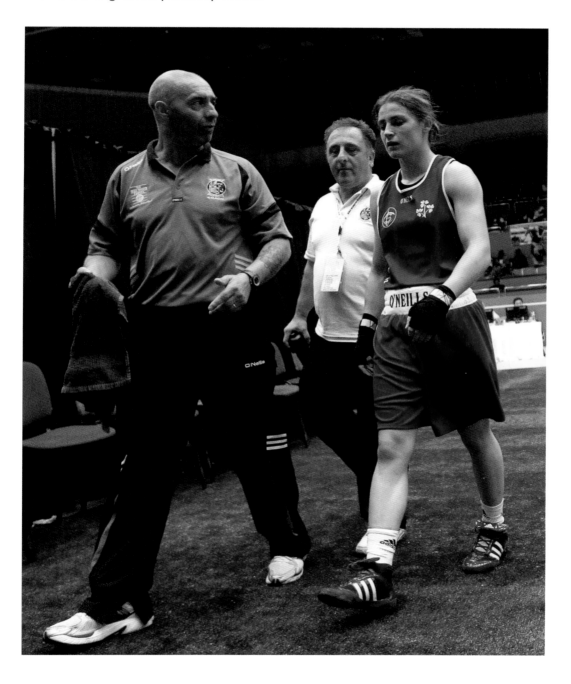

The AIBA Women's World Boxing Championship statue outside the Garfield Sports Complex in Bridgetown, Barbados.

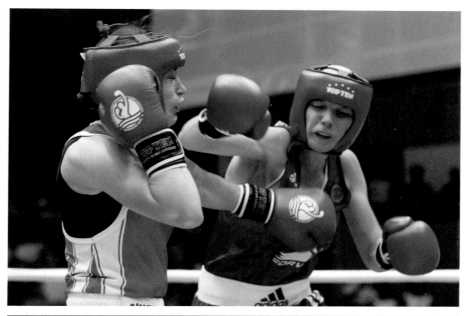

The result was never in doubt for a moment. Katie (in red) guaranteed herself at least a bronze medal after she scored another comprehensive victory of 16–1 over Russian opponent Anastasia Belyakova in the quarter-final of the AIBA Women's World Boxing Championship 2010.

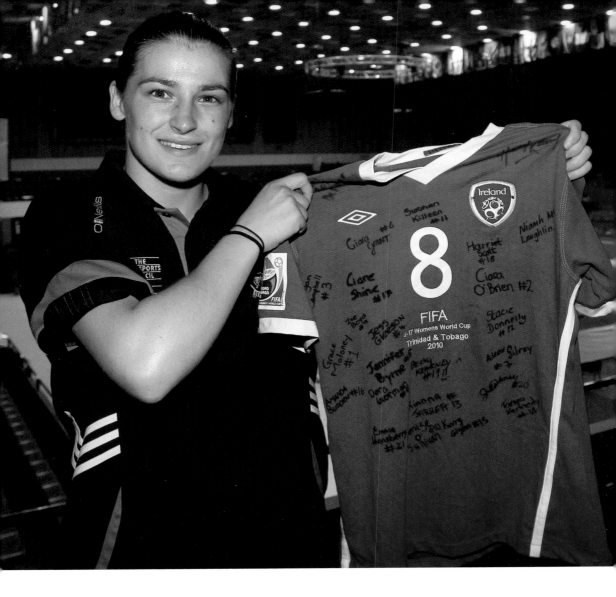

As someone who played soccer for her country, Katie was thrilled to receive the thoughtful gift of a signed jersey from the Republic of Ireland's U-17s when she was in Barbados for the AIBA Women's World Championship in 2010. While Katie was focusing on winning her third consecutive world title, the Irish team were over in Trinidad and Tobago to compete at FIFA's women's U-17s final, which was won by Korea Republic. For the record, the Irish team topped their tough group, which included Brazil, by winning two out of three of their group matches. But, sadly, they lost their quarter-final game 2–1 to Japan, who lost out on penalties in the final to Korea Republic.

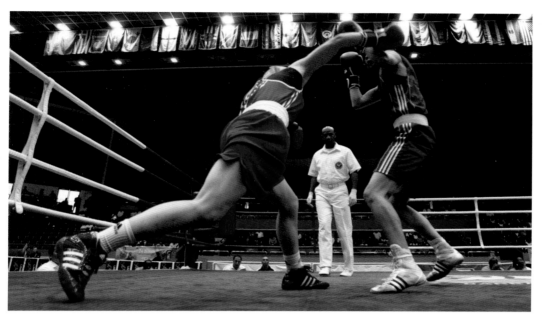

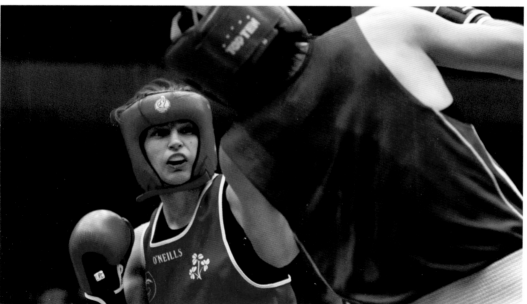

Katie impressively marked her one hundredth career win in the final of the AIBA Women's World Boxing Championship 2010 final when, once again, she defeated China's Cheng Dong – this time with a scoreline of 18–5. It was a victory that silenced the crowd. Katie would defeat her Chinese opponent the following year by an even larger margin of 11–0.

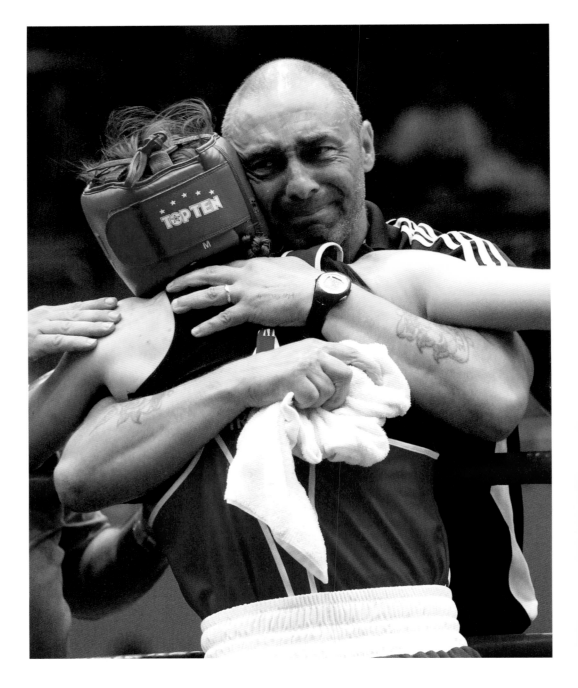

An emotional Peter embraces his daughter Katie after she wins her third consecutive world title in the 60 kg category at the sixth AIBA Women's World Boxing Championship 2010.

An emotional Katie rejoices in her victory by retaining gold at the
AIBA Women's World Boxing Championship 2010. It was the third
major title Katie won that year – she also won gold at the European
Union Championship in Poland and retained her European Amateur
Championship title in Rotterdam. Two years later would be even more
special for Katie when she would go on to win her fourth successive
world title in China and then gold at the Olympics.

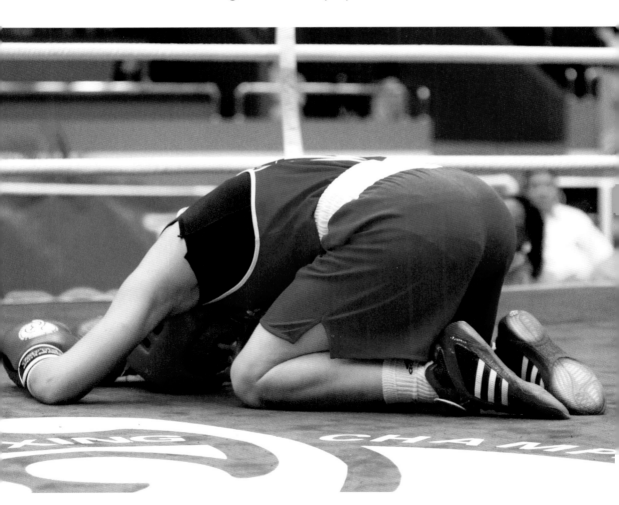

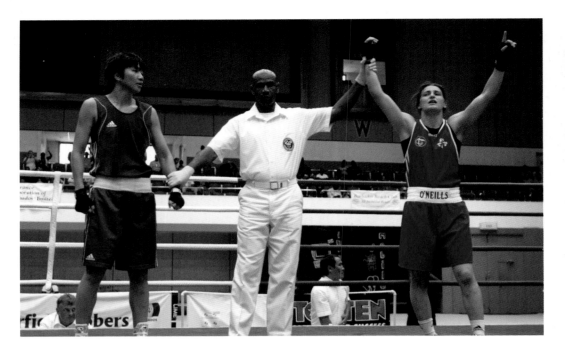

Katie wins a gold medal after winning her third successive world championship at the sixth AIBA World Women's Championship 2010 in the 60 kg division.

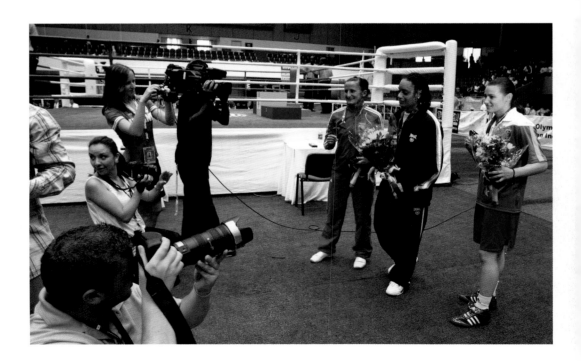

ROUND 7 – BEST BOXER

Once again, Katie was given the award for Best Boxer (which she received from AIBA President Dr Ching-Kuo Wu at an event in Almaty, Kazakhstan) after winning gold at the AIBA World Women's Championship 2010. 'I would like to thank AIBA for this award. It's a huge honour to receive this above all the great female boxers in the world,' Taylor told the audience. 'I'm so happy that women's boxing is included in the London Olympics and I would like to collect this award on behalf of everyone who made that happen. In London 2012 we are going to show the world what women's boxing can do.'

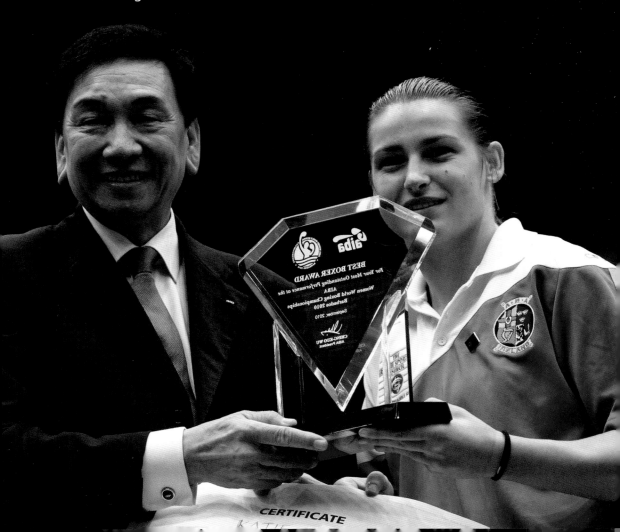

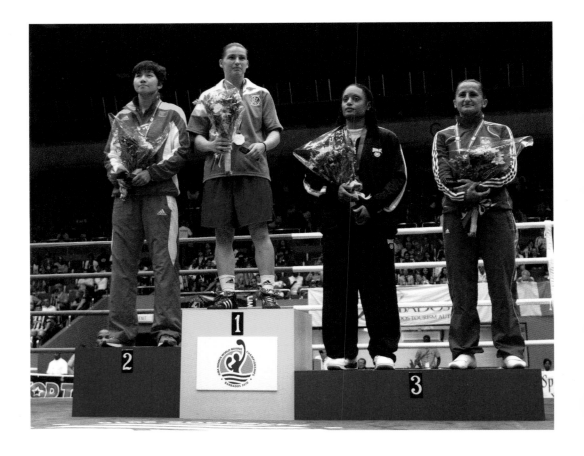

Katie stands on top of the podium with her gold medal at the AIBA World Women's Championship 2010. The silver medallist, Cheng Dong of China, beaten 18–5 by Katie in the final, is pictured on the left. The two bronze medallists were Quanitta 'Queen' Underwood of the USA, who was once believed to be Katie's closest rival for gold at the London Olympics, and Karolina Graczyk of Poland.

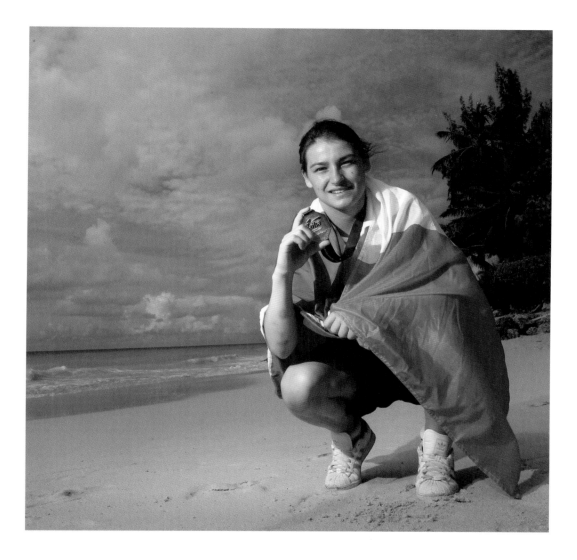

A proud world champion poses with her gold medal on the beach in Barbados with the tricolour wrapped around her. The picture was taken the day after the final of the AIBA World Women's Championship 2010. Katie would go on to win the title for a fourth successive time in 2012 – meaning that she has now won four out of the six world championships for women boxers that have been held to date. It's an astonishing record, and one that will probably never be repeated.

Katie poses for photographers in Barbados the day after winning
the word title for a third time in 2010.

Signing an autograph for clearly thrilled seven-year-old Isobel Doyle at the rapturous homecoming celebrations at Dublin Airport to mark Katie's historic achievement in retaining the world title for a third time in succession in 2010.

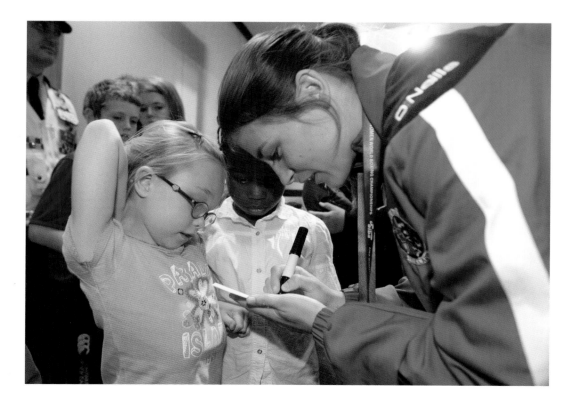

Katie was selected Boxer of the Year – one of the top eight Irish sports stars chosen in different disciplines – to receive the 2010 Texaco Sportstars of the Year Award. Katie is pictured at the event, held in November at the Four Seasons Hotel, accepting her award, alongside Dora Gorman, accepting the Team of the Year award on behalf of the Republic of Ireland's U-17s team, and Lar Corbett, who was awarded in the Hurler of the Year category. The other six sports stars selected for the 53rd Texaco awards event were chosen by sports editors from the print and broadcasting media and included: Derval O'Rourke for athletics, Bernard Brogan for Gaelic football, Graeme McDowell for golf, Tony McCoy for horse racing, Tommy Bowe for rugby, and Grainne Murphy for swimming.

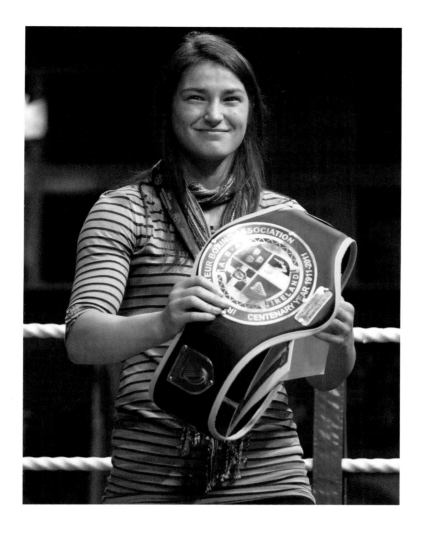

Katie after winning the final in the 60 kg lightweight category at the 2011 Irish Elite Championship. The following year, Katie opted not to contest the final. It had been an unwritten rule that the national champion would be selected to represent Ireland at major championships, but it was agreed that Katie could forfeit in 2012 in order to focus on retaining her world title, as it was felt that it would be better not to disrupt her preparations for the World Championship. 'The fact of the matter is that Katie is in a different league from the rest of the girls in Ireland,' explained Billy Walsh of the IABA.

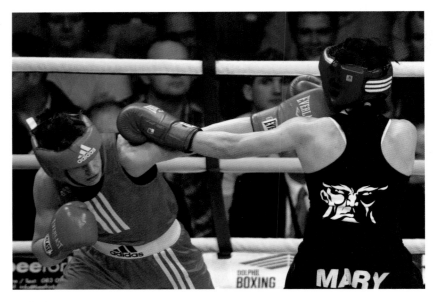

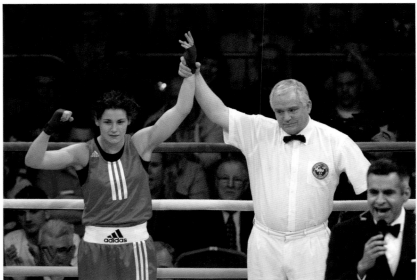

Katie defeated Swedish champion Helena Falk (in black) when she was added as the undercard to the WBA super bantamweight title fight. The champion Guillermo Rigondeaux defended his title against Willie 'Big Bang' Casey at the CityWest Convention Centre in Dublin in March 2011. Katie sparred with the world and double Olympic champion Rigondeaux when he visited Limerick a few weeks prior to the fight night.

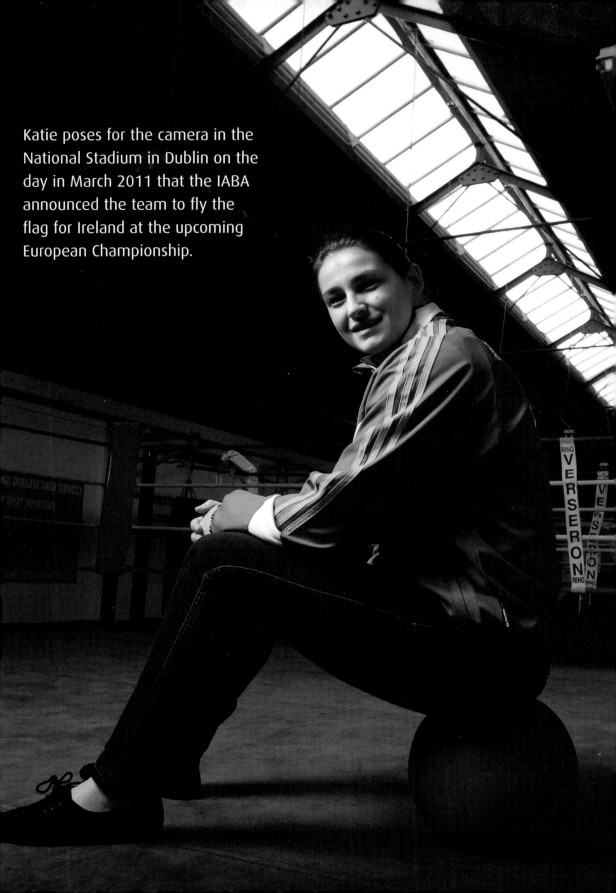

Katie poses for the camera in the National Stadium in Dublin on the day in March 2011 that the IABA announced the team to fly the flag for Ireland at the upcoming European Championship.

Katie in action as she comprehensively defeated Holland's Vandellen Willeke with a score of 22–4 at the IABA Open unseeded competition finals at the National Stadium in Dublin, March 2011. But even though she comfortably controlled the majority of her fights – such as this one against Willeke – her father Peter says he wouldn't be afraid to throw in the towel if his daughter was to come undone in the ring. 'I'm just so proud of her. I'd be protective too – because while she has been successful, I'd be the first to step in and stop a fight if she was getting hurt. Some coaches, mainly in the professional game, would let their fighter get killed. They wouldn't show any compassion. But I'd never see Katie get hurt,' he once revealed.

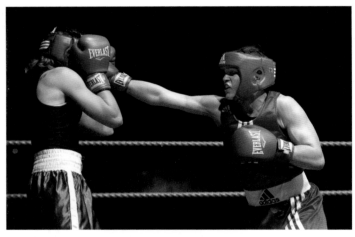

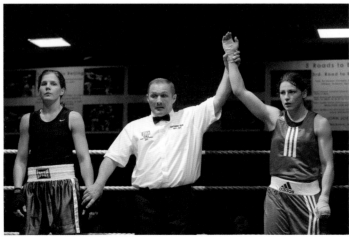

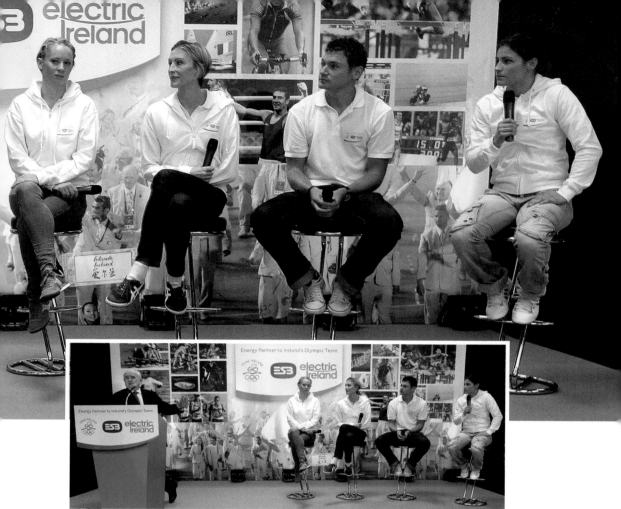

Katie answering a question posed by Jimmy Magee at the Olympic Council of Ireland media launch in September 2011 to announce Electric Ireland as a sponsor of Team Ireland for London 2012. 'All I want is to box. The Olympics is the dream and has been since I was a little girl. I would have been heartbroken if I never got the chance to fight in the Games,' she explains.

'As a little girl I watched all the Games. Sonia O'Sullivan winning silver in Sydney was my inspiration. She did it under pressure. I suppose I am under pressure too – because everyone always expects me to win. But the standard of these girls is getting better and better all the time, so it's important I keep a few steps ahead.'

Also in the picture are Irish Olympic athletes Derval O'Rourke, Deirdre Ryan and David Gillick.

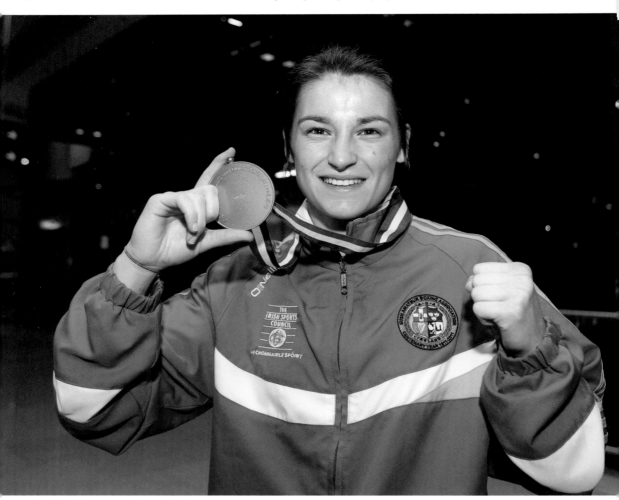

A proud Katie arrives home with her fourth successive gold medal from the European Championship in Katowice, Poland, in October 2011. She convincingly beat the hometown challenger Karolina Graczyk 25–9 in the final. Afterwards, Irish team manager Majella Loftus paid tribute to the champion: 'Katie boxed out of her skin. She was 5–1 ahead after the first round and she just kept getting stronger and stronger after that. It was a fantastic all-round performance.'

Dominic O'Rourke, Director of Boxing with IABA, told the press: 'Katie was absolutely brilliant. She produced another fantastic performance today. She showed great balance and coordination in the final. She peaked over the last two days at these championships and we're thrilled with the win.'

Katie was awarded the Sportswoman of the Month prize for May 2011 at the annual Irish Times/Irish Sports Council Sportswoman of the Year event held in December 2011. The award was established in 2004 with the aim of recognising the 'abilities and achievements of women in Irish Sports'.

Taoiseach Enda Kenny presents the award to Katie Taylor, alongside the editor of *The Irish Times*, Kevin O'Sullivan, and Kieran Mulvey, chairperson of the Irish Sports Council.

Katie won the award again – for the fifth time – for the month of May 2012. After receiving the award, as she headed to the London Olympics, Katie said: 'I'm delighted to be going to the Olympics in the best shape I've ever been in and as the current world champion. I cannot believe it has happened but it has been my lifelong dream to box in the Olympics and promote women's boxing. I will improve again over the next few weeks and I hope to come back with that gold medal for my country.'

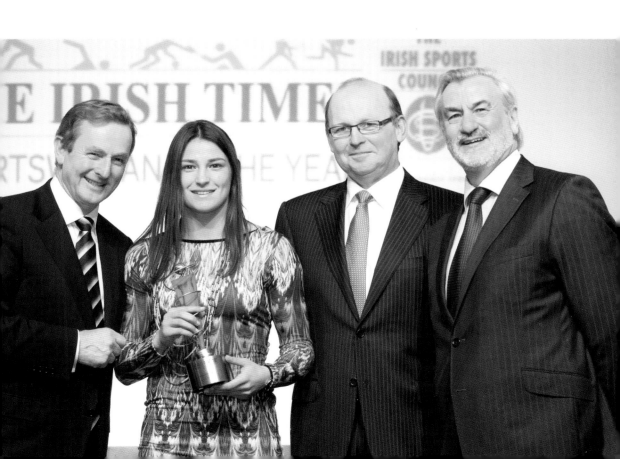

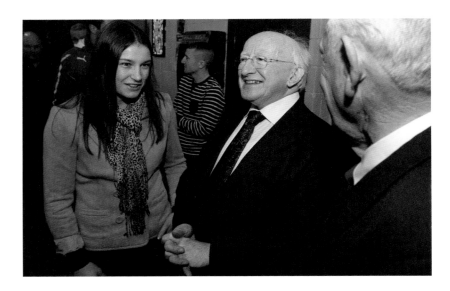

Katie chatting with President of Ireland Michael D. Higgins before the 2012 Irish National Elite Senior Boxing Championship Finals in March. Katie had decided not to contest the final while preparing for the World Championship.

Peter Taylor and Zaur Antia watch Katie's fight at the AIBA World Women's Championship Preparation Bout at the Royal Hotel in Bray, County Wicklow, March 2012.

Katie in action for yet another victory over Sandra Brugger of Switzerland, at the AIBA World Women's Championship Preparation Bout at the Royal Hotel in Bray, March 2012. It was the fourth time Katie had beaten her Swiss opponent. Katie defeated Norway's Ingrid Egner the following night, at the same venue, for the third time – the first victory was at Katie's first full international bout in Oslo back in 2004, and the second occasion had been a split decision in 2010.

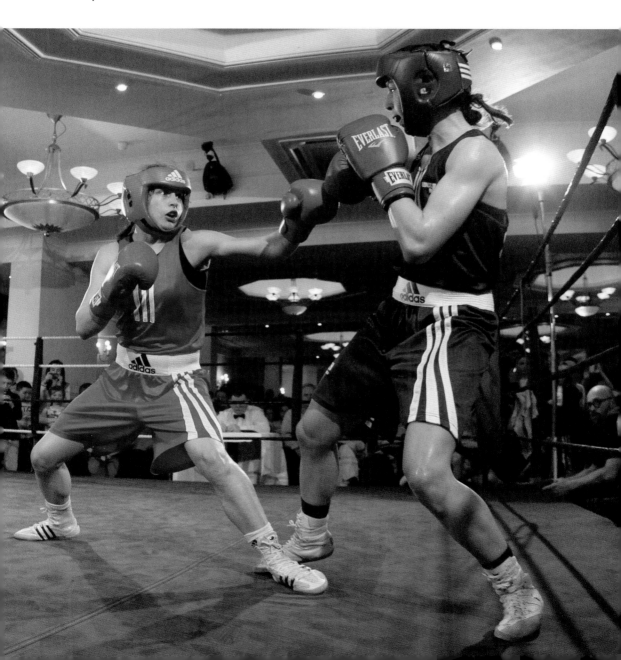

Katie fought Jessica Belder in one of seven fights in the Ireland vs Holland international in March 2012. It was the first time that Katie had fought in an international competition at the National Stadium, Dublin. Katie easily outboxed her Dutch opponent 27–4 on the night. Katie had beaten Belder by a massive score of 21–1 when the two women had last touched gloves in October 2011. Ireland had three wins on the night.

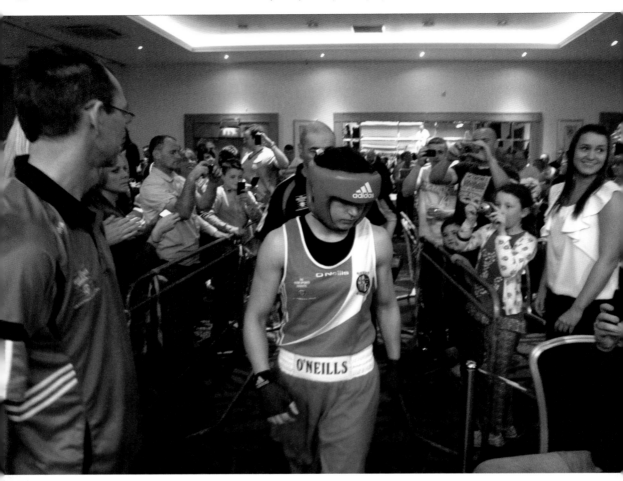

The Silver Springs Moran Hotel in Cork was packed to the rafters for Katie's pre-Olympic fight against the US National Champion Liz Leddy at the end of March 2012. It was Katie's third win in seven days.

'I'm very happy with that performance. Liz Leddy was great. It's very useful to box against the different styles. We knew what to expect when fighting her – it was non-stop attack for four rounds. But we did well – our tactics were perfect,' Katie said graciously after the fight.

'The crowd were unbelievable. They always get behind you so much in these kind of nights. It was an amazing atmosphere to fight in, which helped make the night so enjoyable. I think I've fought in Cork four or five times now and each time it is fantastic.'

ROUND 8 – ANOTHER VICTORY IN CHINA

2012 was potentially the biggest year of Katie's career – with the European Championship, World Championship and Olympics all within her grasp. But, as Katie told the press after a fight in Cork 2012, she certainly wasn't counting any chickens before they hatched and insisted that she was determined to focus completely on retaining her fourth world championship, pointing out that she hadn't even qualified yet for the Olympics. Katie is pictured on her way to victory against Saida Khassenova of Kazakhstan to book her place in the lightweight quarter-finals at the AIBA World Boxing Championship, at the Olympic Stadium, Qinhuangdao, China, 15 May 2012.

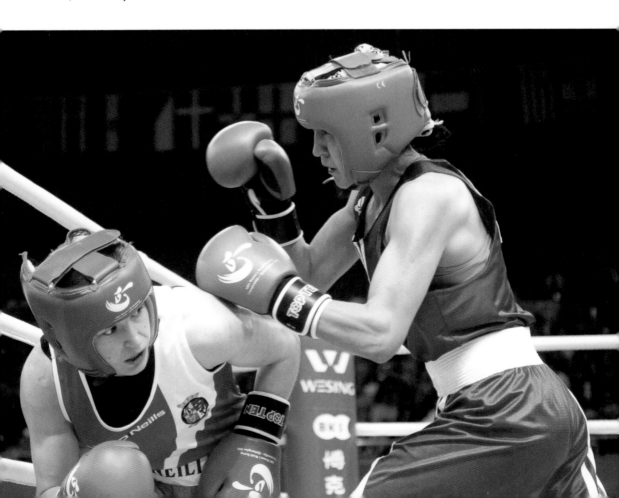

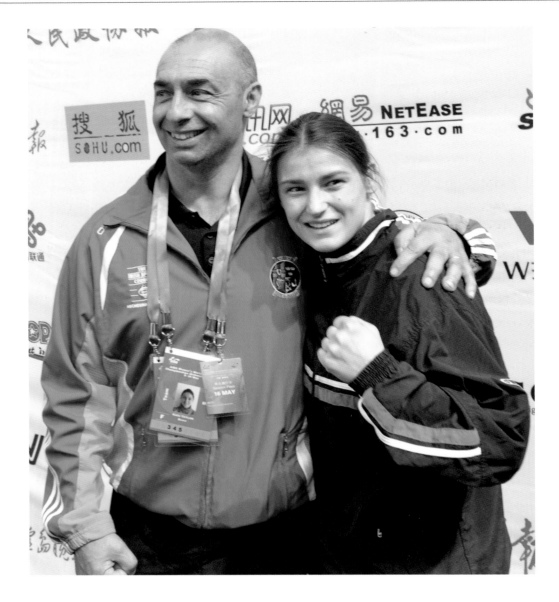

Katie and her father Peter are all smiles on 16 May 2012, when it's confirmed that she has qualified for the London 2012 Olympic Games. It was a dream come true for them. When Katie was 11, Peter had told RTÉ: 'I'd like to see her in the Olympics. Hopefully she'll go that far, we'll have to wait and see.' The waiting was now over. This picture was taken the day after her victory against Saida Khassenova of Kazakhstan, at the Olympic Stadium, Qinhuangdao, China.

As in the future Olympic final, Katie met her Russian nemesis Sofya Ochigava (in blue) in the final of the AIBA World Boxing Championship in China, 2012. Katie beat the Russian southpaw – three times European champ and twice world champ – by a margin of 11–7, winning two rounds and drawing two rounds. It was Katie's thirteenth gold medal in total. The Olympic final would have an even tighter scoreline of 10–8. This World Championship victory was the second time in succession that Katie beat Ochigava, with the two also meeting in the European Championship final in Rotherham.

Reflecting on the European final, Katie's mother told Andrea Smith of *RSVP* magazine: 'Katie and Sofya were both at opposite ends of the draw, so there was a lot of talk about the possibility of them meeting. Everyone was looking forward to it, and when it came around, obviously we were nervous because the girl had been boxing well through the tournament. She's a very tricky boxer who leads with her right hand – an orthodox boxer leads with their left hand – so that makes it more difficult. I think Pete got the tactics just right, because he said that Katie had to use her feet and be patient and not rush in – it was a very tactical fight and it was exciting to watch and we didn't relax until it was over. We were really elated for Katie when she won – it was brilliant.'

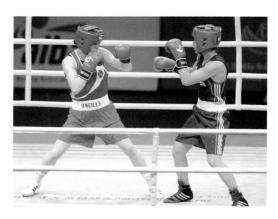
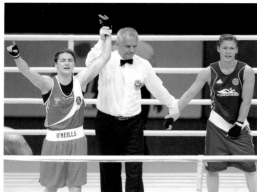

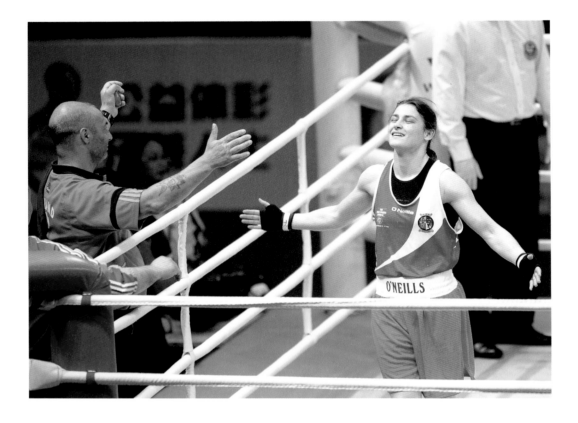

Katie goes over to her corner to celebrate her fourth successive world title – an unprecedented achievement – with her father after beating Sofya Ochigava in the final of the AIBA World Boxing Championship in China, 2012. It was a win that gave her a bye into the quarter-finals of the Olympic Games, which was something Katie admitted that she was unaware of until after the fight.

Katie and her father embrace as she shows off her gold medal at the AIBA World Boxing Championship in China, 2012. 'It was a tricky fight. It was just a game of patience and nerves in the end. Thank God for the victory. I'm delighted,' Katie told the press. 'In those kind of fights you don't know what is going to happen. One or two points makes the difference. You have to have so much concentration and discipline. These kind of fights prove how great women's boxing is.'

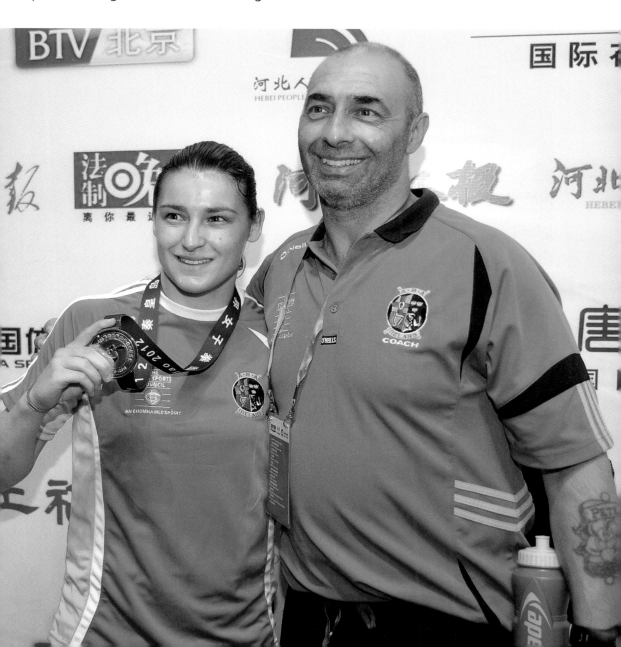

After winning her fourth world title in May 2012, Katie told the press that she was dying to get home so she could meet her two-week-old niece, Hope Taylor.

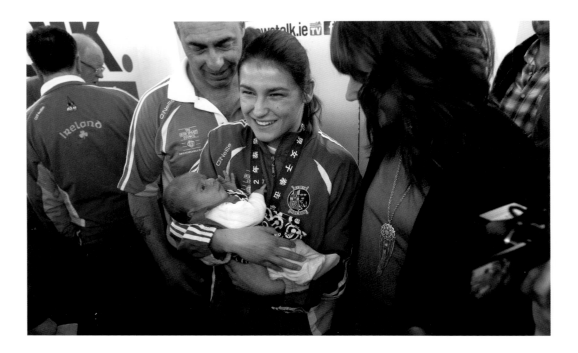

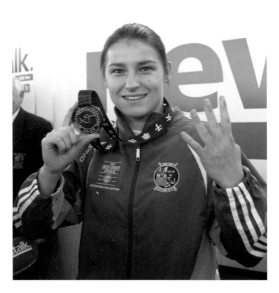

During the homecoming celebrations Katie holds up her gold medal and four fingers to indicate it was her fourth successive world championship title. After her victory, Taoiseach Enda Kenny released a statement hailing her momentous achievement: 'This was another brilliant performance. Katie is an outstanding and true champion. She has made us all proud and lifted the heads of the Irish people.'

ROUND 9 – OLYMPIC TORCH

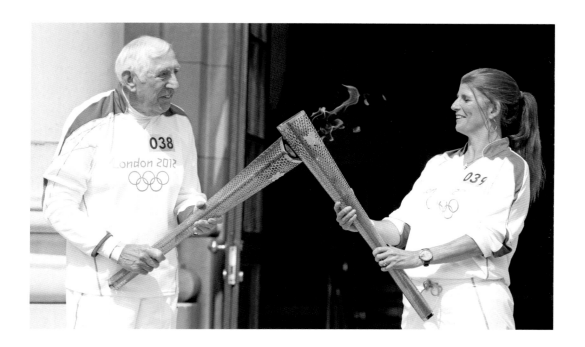

Katie's mother Bridget had the great honour of carrying the Olympic torch when it arrived in Dublin on its way to the London Games on 6 June 2012. She is pictured receiving the torch from 1956 Olympic gold medal winner Ronnie Delany outside Government Buildings.

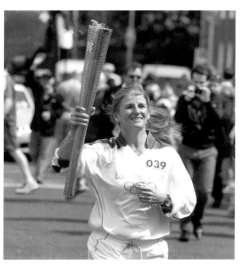

'We will never have the Olympic Games in Dublin and the nearest we are ever going to come to it is the London Games,' said Olympic Council of Ireland President Pat Hickey. 'To have the torch relay in our part of the island is quite unique and historic, and I think in years to come people will look back and say, "That must have been great".'

The Bray Boxing Club opened its doors to the media to show Katie in a training session – she is pictured sparring with Adam Nolan – following a badly needed refurbishment project that was carried out on the facility.

Taoiseach Enda Kenny had been in shock, according to Peter Taylor, when he paid a visit to see Katie training, only to discover that for the past five years the world champion was forced to go without toilet or shower facilities at the Bray Boxing Club, which the press described as a 'decrepit building'. The government gave a grant of €24,000, but it wasn't enough to carry out the entire refurbishment project. Thankfully, the club then received a further €7,000 donation from the proprietor of Mallon Sausages in County Monaghan to help improve the facilities.

Peter, who had founded the club, said that the poor facilities had had an adverse effect on his daughter's health and had even affected her performance in the ring.

'In the past we'd be halfway through a session and Katie would have to walk to a local pub called the Harbour Bar. It caused her to get cold because leaving the club after sweating isn't a good idea; it was a nightmare and impacted on her training.'

Katie arriving with her father Peter at Heathrow Airport ahead of the opening ceremony for the London 2012 Olympic Games. Peter was already telling the media that he hoped his daughter would retire after the Olympics. 'I'll be delighted when she does retire as it will be a lot of stress off me. I hope she retires after the Olympics. But it's going to be Katie's decision and I'll back her 100 per cent.'

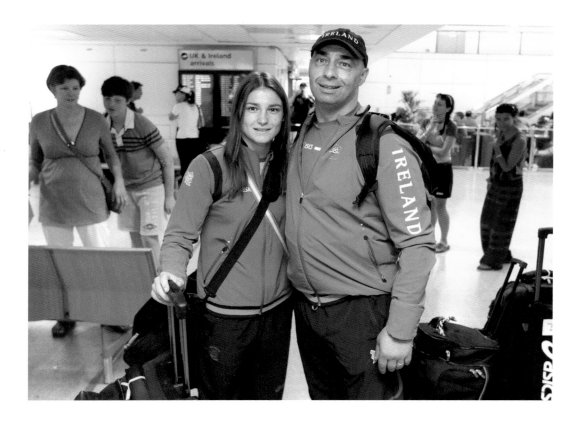

ROUND 10 – 2012 OLYMPIC GAMES

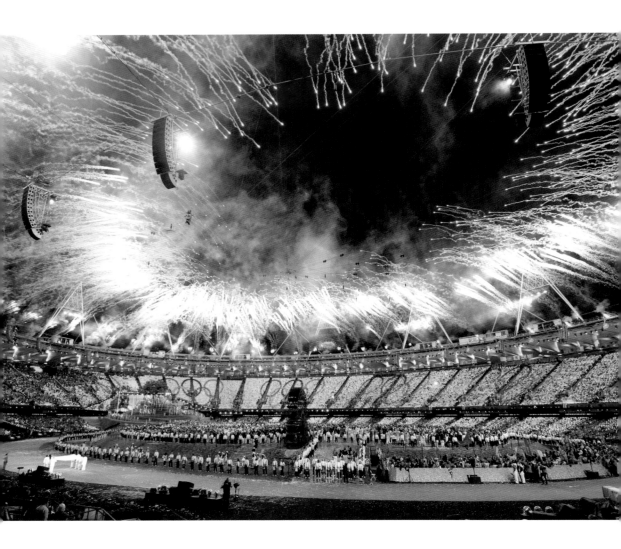

The spectacular fireworks display at the opening ceremony of the London Games on 27 July 2012. The world's top athletes, from more than 200 nations, were welcomed at the opening ceremony, titled 'Isles of Wonder'. It was the third time that the English capital hosted what is the world's biggest and most important sporting event. It was estimated that over 300 million people watched the event.

Flying the flag for Ireland...a proud Katie had the wonderful honour of leading out the Irish team at the opening ceremony of the Olympic Games at the Olympic Stadium. 'It's a privilege to be here to box for my country. I've never experienced an atmosphere like this before. It's a dream for me,' Katie said afterwards.

Her father Peter told the *Irish Daily Mail* that Katie 'hadn't realised the sheer scale of it until she did it. But it was an amazing experience for her.' Katie told him that carrying the tricolour was the 'proudest moment' of her career.

Katie was only the third boxer ever to carry the Irish tricolour in the opening ceremony – following in the footsteps of Olympic silver medallist Wayne McCullough, who was given the honour at the 1988 Games in Seoul, and Francis Barrett, who carried the flag at the 1996 Olympics in Atlanta.

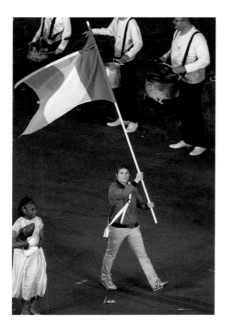
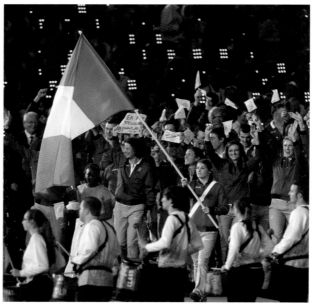

Katie receives a thunderous welcome from Irish fans as she makes her way into the ring at the ExCel Arena with her father and coach Peter and technical and tactical coach Zaur Antia for her first Olympic fight against Great Britain's Natasha Jonas, on 6 August 2012.

The world champ might have been awarded a bye into the quarter-finals, but the draw itself 'had not been that kind', Katie's father told the press, with her being paired with the highly rated slugger Jonas.

'No, it's not been kind, but it's not been kind to the other girls; that's the way I look at it. Nobody wants to be on Katie's end of the draw. It's not good for the other girls. Every fight is a final, every fight is a gold medal fight. It makes no difference to us,' a philosophical Peter told the *Irish Daily Mail*.

'You've got to beat everybody if you want be an Olympic champion, so it makes no difference if you get them in the first fight or the last fight, to tell you the truth. I just think it's great. It enables Katie to show the world what female boxing is all about and that it's not been a shoo-in in all these competitions – they're difficult to win.'

Katie met Great Britain's Natasha Jonas in the electrifying quarter-finals at the ExCel Arena. The noise in the arena was recorded at 113.7 decibels – a noise level that is four decibels greater than the human pain threshold. Katie was really surprised by the huge level of support for her, as she had anticipated that the majority of the audience would be there to cheer on the hometown pugilist.

Her father insisted that Katie was mentally prepared to meet a hostile crowd. 'People are wondering how she will feel if she has to fight the English girl, Natasha Jonas, in her quarter-final in front of a lot of people who will want her to lose. Katie can't think of anything better. She thrives on that sort of adversity, as she showed in the World Championship final in China when she was up against Cheng Dong, and beat her comfortably to silence the crowd. So bring it on, she said after the draw...' Peter told Jonathan Coates of the *Irish Daily Mail*.

'She never wanted an easy ride at these Olympics, because if she got that it might show women's boxing in a poor light when, for the first time, the whole world is watching.'

But the crowd was predominantly Irish; while back home, over 6,000 fans lined the Bray seafront to cheer on their hometown hero. It also turned out to be a relatively easy bout for Katie. Apart from a brief spell in the second round, the Irish hero was in control for the entire eight minutes of the fight, as Irish fans, who outnumbered the British in the arena, chanted a deafening chorus of *olé, olé, olé*.

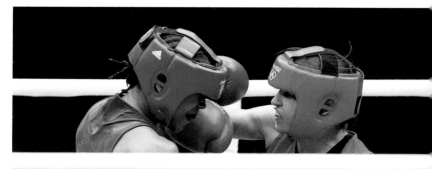

ROUND 11 – NEARLY THERE!

Katie comfortably won her quarter-final bout against Natasha Jonas by an impressive scoreline of 26–15. 'She's a super boxer and a fantastic person. I had to work so hard. She wasn't hurt at all. I am just delighted with the win,' a modest Katie commented after the fight.

Afterwards, a gracious Jonas – who received two standing counts after feeling the feel force of some thunderous right-hand punches from Katie – reflected on the fight. 'I will make no excuses. I have come here feeling the fittest, the leanest, the healthiest, smartest boxer I could be but she is still the best. I take my hat off to her. There was nothing else I could do. I could've thrown the kitchen sink at her or maybe driven a bus into her. I hope she goes on to win it.'

The following day's *Guardian* newspaper described Katie as 'the best female boxer there has ever been or, possibly, ever will be'.

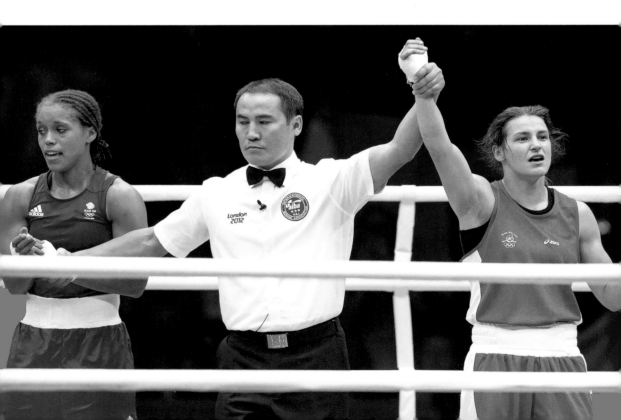

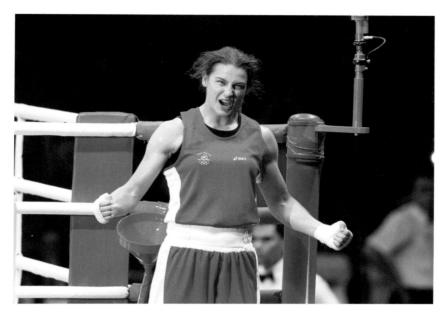

An elated Katie wildly celebrates her quarter-final win, which meant that she would be guaranteed at least a bronze medal going into the semi-finals. 'It was unbelievable here, I couldn't wait to get out. I just tried to stay calm and composed throughout the whole thing but it was hard not to get excited at the end,' she told RTÉ Sport.

Katie talks with Team Ireland boxing coach Billy Walsh before her quarter-final victory at the Olympics. A confident Katie believed it was her destiny to win the first ever gold medal for a woman boxer in the 60 kg lightweight division. 'I am here to win gold – nothing else. Anything other than a gold medal will be disappointing. At the end of the week, I will be an Olympic champion.'

The moment the bell went in the first round of her semi-final bout in the Olympics, a confident Katie burst out of her corner, attacking her opponent Mavzuna Chorieva of Tajikistan, who was unable to respond to the mounting pressure. The world champion took a 3–1 lead after the first round.

It was almost as if Katie was playing to her ecstatic audience – who once again were mostly Irish, there to cheer her on – with her mesmerising sleek footwork. Katie gathered up many of her points with her left hook, as a nervous Chorieva tried to avoid the world champ's deadly right hook. Katie extended her lead in the second round with two devastating punches that took it to 7–3. Katie's advantage stretched to 13–6 in the third round.

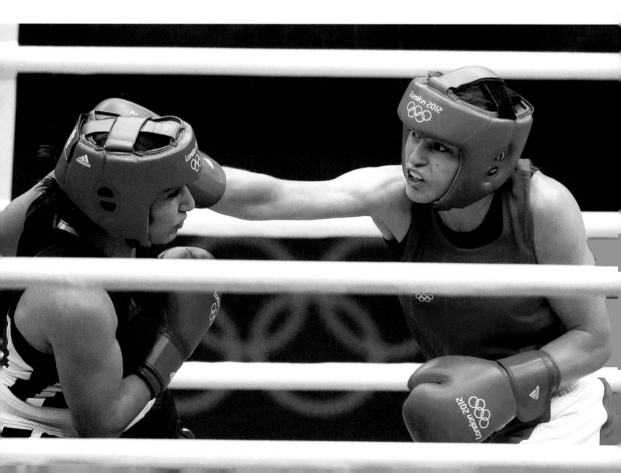

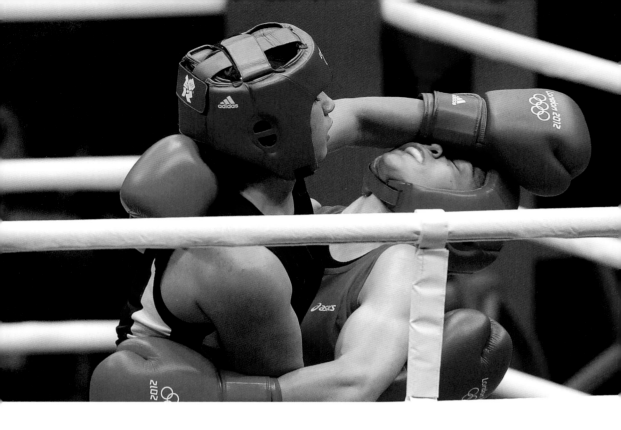

Katie was clearly angered by her opponent's mind games tactics and the referee twice had words with Chorieva for feigning a drunken shuffle. At one stage she even appeared to stick her tongue out at Katie.

Chorieva tried in vain to close the gap in the final round, but Katie remained poised and in control of the semi-final on 8 August 2012. Reflecting on Chorieva's unsporting behaviour, Peter Taylor said: 'We spoke to Katie about it before the fight. But, when you're winning by four or five points, why would you get annoyed over it?' After the fight, Katie gave her own views: 'My dad told me before that she was going to do things like that and she's very dirty in close as well, we knew she was going to get a bit physical in close, but I just had to stay calm and composed. She was trying to wind me up from the very start, but I just kept to my boxing, really.

'Experience definitely helps. I boxed her in the world championships and she was kind of doing the same as well. So I knew what to expect and I'm just delighted I'm boxing for a gold medal now. This is what I've dreamed of my whole life, to be honest.'

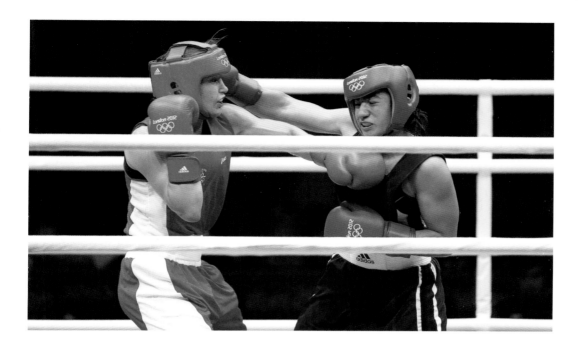

Katie comfortably won her Olympic semi-final with a score of 17–9. The victory was never in doubt, with Katie dominating her opponent, who had the consolation prize of making history in her own right by winning her country's first ever medal (bronze) at the Olympics.

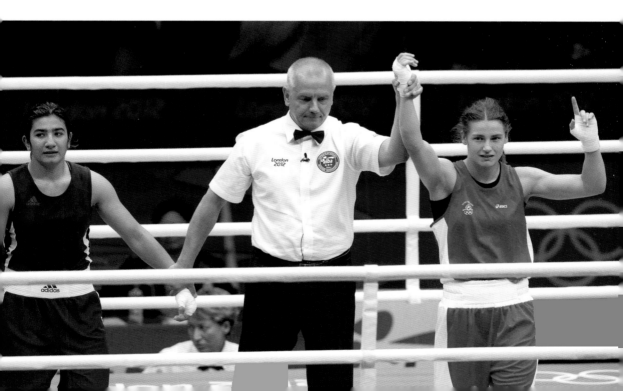

Katie receives some hugs and kisses from her father and coach Peter, and her technical and tactical coach Zaur Antia, after her semi-final victory, which at least guaranteed the world champion a silver medal at the Olympics. But Katie was determined to win gold.

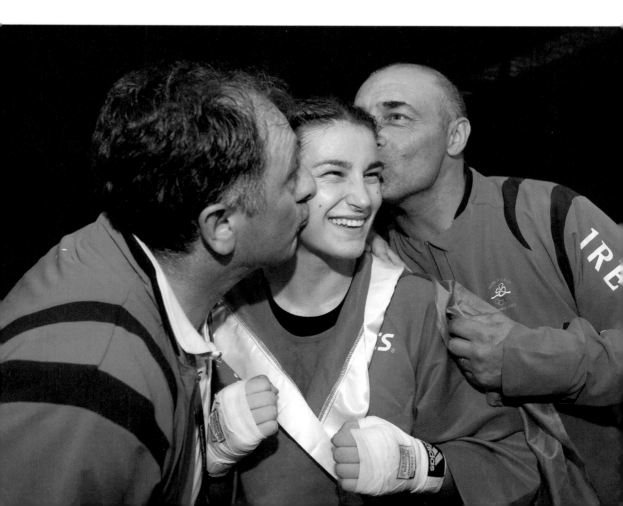

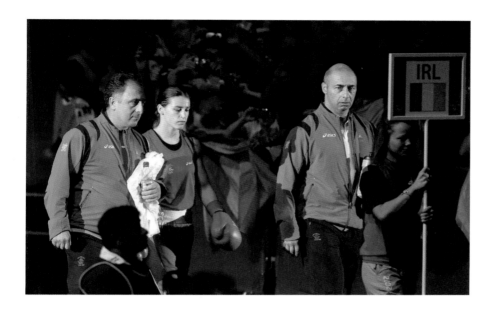

The moment of truth…Katie arrives in the ExCel Arena for the moment she has been dreaming of since she first took up boxing – to participate in an Olympic final. 'People often ask me if Katie gets nervous before her fights. She does but she has learnt how to block it out and focus on what she has to do,' Peter told Jonathan Coates of the *Irish Daily Mail*.

But she wasn't able to 'block out' her nerves on this momentous occasion. The usually confident-looking Katie was visibly apprehensive before the start of the final against her Russian counterpart Sofya Ochigava, who had once beaten the Irish world champion.

'I was so nervous; it was the most nervous I've been for a fight. I had a knot in my stomach all day. It was hard to relax, I couldn't even eat all day. But when I got in there it was just like any other contest,' Katie admitted.

After hearing that she would be meeting her Russian foe in the final, Katie admitted that it would be a 50/50 fight. 'The pressure is always going to be on both boxers as we are both boxing for gold,' Katie said.

Her father Peter had spent the night before the final repeatedly watching the Russian boxer's semi-final against Brazilian Adriana Araujo. It was a very tight bout and the Russian was somewhat lucky to come away with a flattering scoreline of 17–11.

ROUND 12 – THE FINAL!

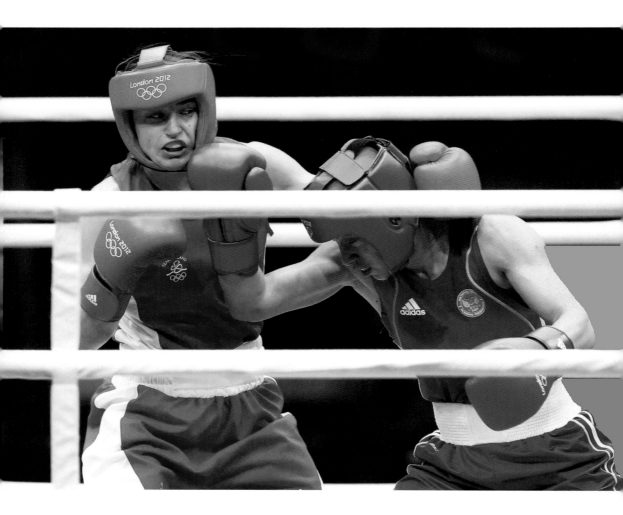

The pressure was clearly telling on Russian boxer Sofya Ochigava, who tried using psychological tactics going into the final by describing Katie as 'just another boxer' and claiming that judges were biased in her favour.

'In my opinion Natasha Jonas won the first two rounds against her, but the judges didn't see it that way. When you fight Katie you are already minus 10 points. You are fighting the judges and the whole system and they will try to give her too many points,' Ochigava claimed bizarrely.

It was a tough, if somewhat unspectacular final – thanks to the Russian southpaw's defensive spoiling tactics and ability to slow the fight down, coupled with a counter-attacking style that definitely troubled Katie.

Both boxers circled each other cautiously in the first round, which ended in a 2–2 draw – giving credence to Katie's view that it would be a 50/50 bout.

The judges inexplicably awarded Katie only one point in the second round, which went in the Russian's favour by a single point to give her a 4–3 advantage against the Irish champ.

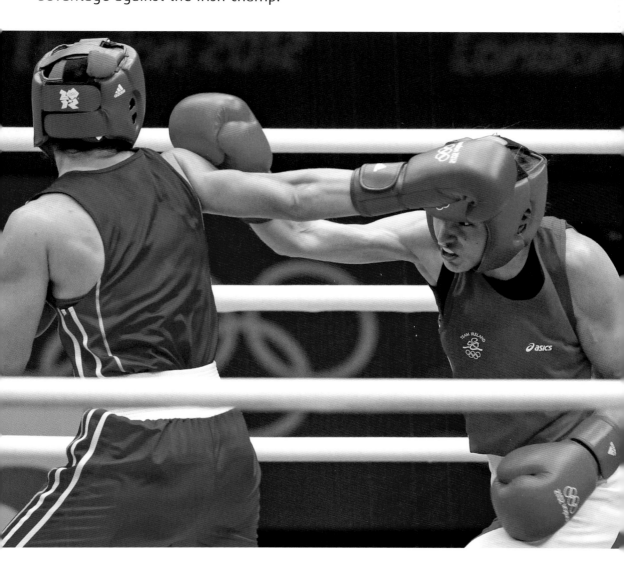

The tension was palpable in the arena as apprehensive Irish supporters started to fear that perhaps it wasn't going to be Katie's day. But a determined Katie didn't disappoint in the third round when she showed her world class by comprehensively out-punching her opponent. The fans erupted when they realised Katie had won that round 4–1, which meant that she was going into the last round with a 7–5 advantage.

The final round was tense and too close to call. The Russian finally opened up and threw herself forward in a last-ditch effort to pull back the score. But it was too little too late. As with the first round, the judges deemed it a 3–3 draw. It was more than enough to give Katie a well-deserved 10–8 victory. The gold medal was finally hers.

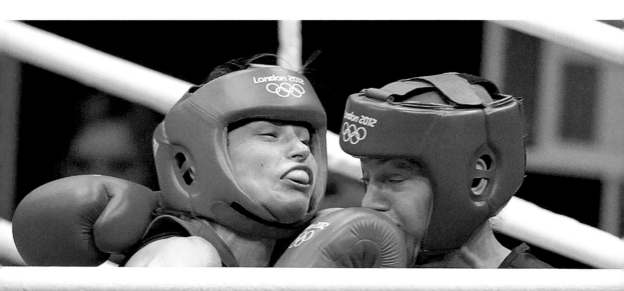
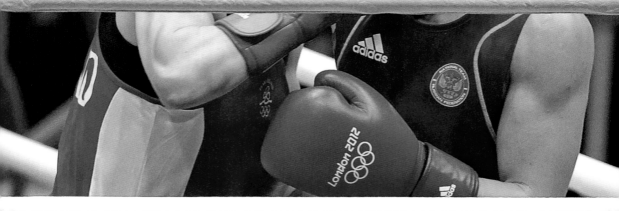

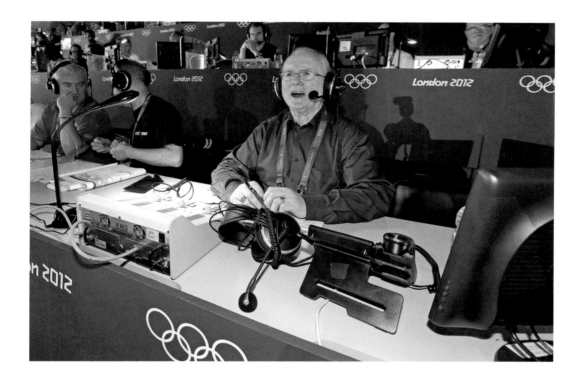

While Katie anxiously waited for the result to be confirmed, RTÉ's broadcaster Jimmy Magee appeared to be doing his utmost to reassure anxious viewers back home that the Irish boxer had achieved her – and by now the entire nation's – dream of winning the Olympic gold medal. 'Surely the gold medal is on its way back to Bray,' maintained Magee.

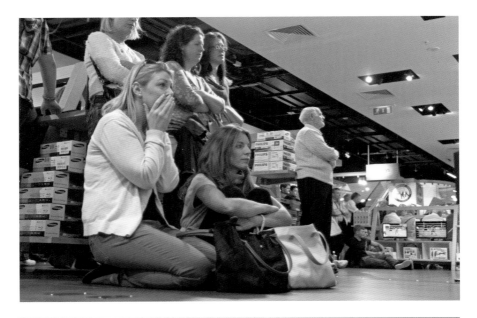

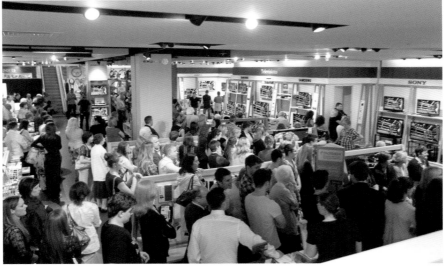

Many workplaces around the country closed early for the Olympic final bout. Here's a view of anxious supporters watching the Katie Taylor final at Arnotts in Henry Street, Dublin. After the result was verified, RTÉ's Jimmy Magee aptly summed up what everybody in the shop – along with the rest of the nation – was certainly feeling: 'I'll bet there's a tear in your eye, wherever you're watching this – but there's nothing wrong with tears.'

Katie wept tears of joy when the final result was announced. It had been an excruciatingly tense wait for her. It was easy to see that she was uncertain about the result after the fight finished – so much so that she had to be reassured by her father that she had actually fulfilled her long-held dream of winning the Olympic gold medal.

Later, Katie explained that while waiting nervously, she thought the result was taking too long and suddenly feared that there could be a countback.

'I didn't know what way the scoreline went,' she said afterwards. 'It was such a close contest really, it could have gone either way. The last round was very close. She caught me with a few punches and I caught her too,' she added. 'There was a bit of a delay and I thought it might have gone to a countback at one stage. I always knew it was going to be close, it always is between me and Sofya.'

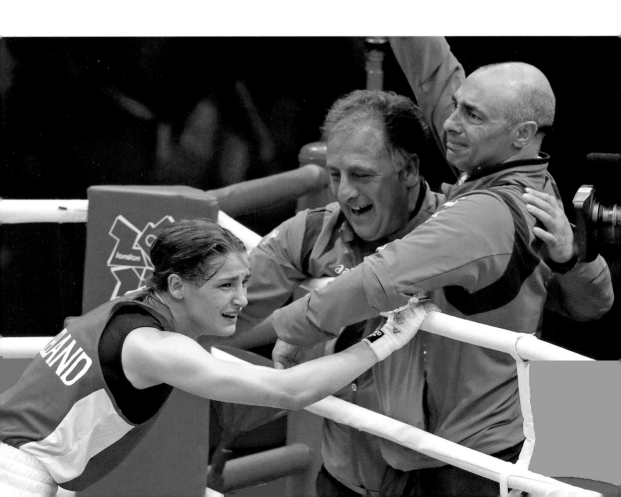

Ecstatic Katie celebrates her Olympic gold medal victory by jumping up and down in the air with joy, before wrapping a tricolour around her. 'I knew Katie would come through. I knew it was her destiny to win the Olympics,' her father said.

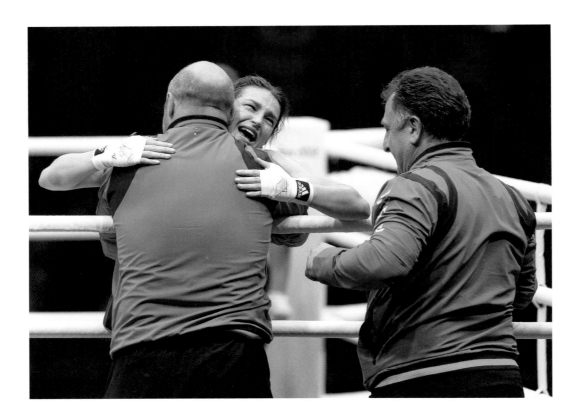

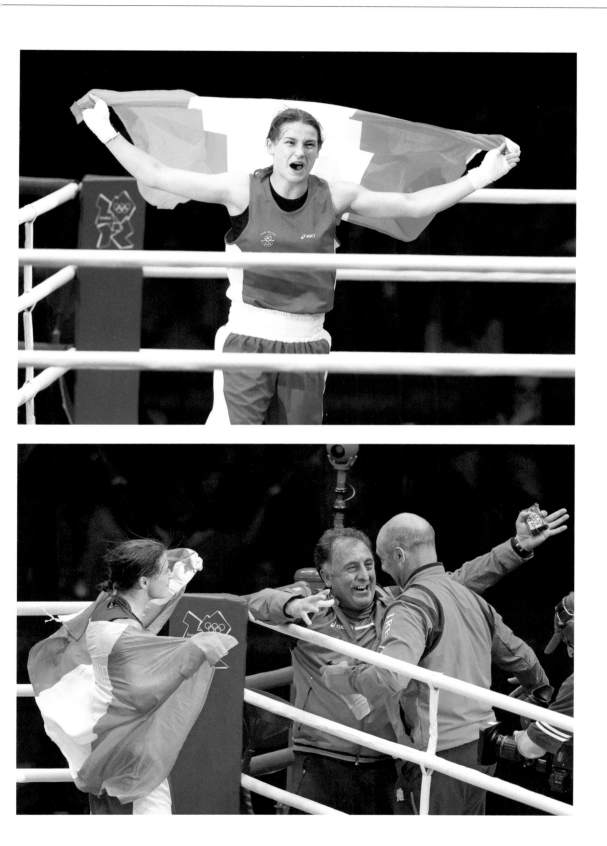

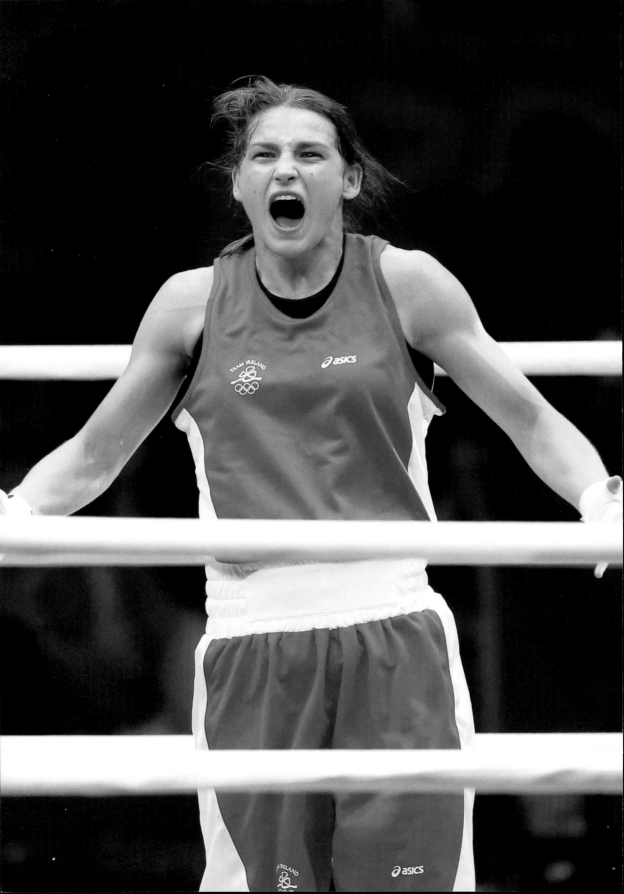

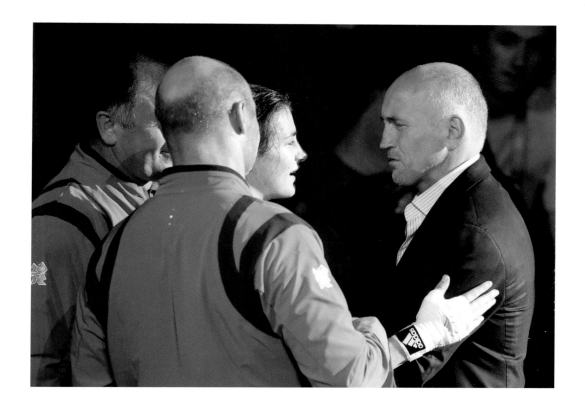

The former world champion boxer Barry McGuigan was overcome with tears of joy as he hugged Katie after she left the ring. He later proclaimed the newly crowned Olympic champion a 'legend'. McGuigan also praised the Irish supporters inside the arena. 'I never experienced anything like it in my life. I don't even think it was like that with me. It certainly surpassed any noise that I heard before.

'She is loved, she is remarkable, she is an amazing kid, she has a lovely family. Just everything that could be said about her I repeat, she's amazing. And I'm so happy for her father, who's committed his life to her. He's a great fella and he's responsible for the level of skill that she has because he just worked the drills over and over and over again. Amazing, just amazing.

'It was a very close fight, and don't get me wrong, she drew the first but could have lost it and she had a poor second but the third and fourth rounds were brilliant and that's what's won it for her.'

The victory still hadn't sunk in when Katie left the arena with her father, who also had tears of joy in his eyes, and a smiling technical and tactical coach Zaur Antia. 'It's what I've always dreamed of. I've envisaged this moment so many times before but it's better than all my wildest dreams to be sitting here as Olympic champion as well as world and European champion,' said Katie.

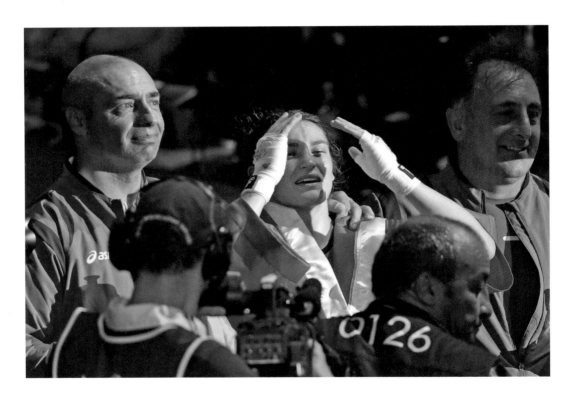

ROUND 13 – THE ROAD HOME

Over 5,000 people gathered on the playing pitches adjacent to the Shoreline Leisure Complex in Bray, County Wicklow, to roar on hometown hero Katie Taylor in her semi-final bouts at London 2012. (Katie herself had cut the ribbon at the centre's opening ceremony four years previously.) But the crowd had easily doubled to 10,000 the next day to watch Katie make history by becoming the first female boxer to win gold at the Olympics. The crowd was clearly tense as they waited for the result after the close final.

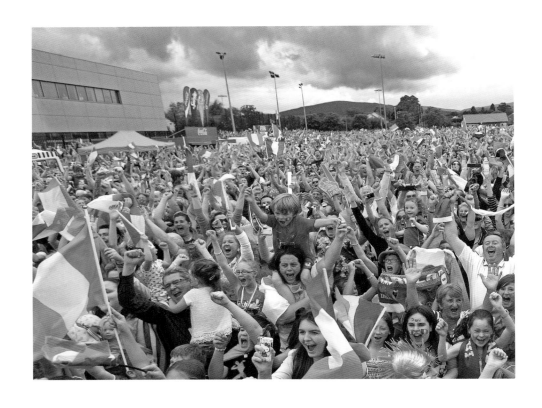

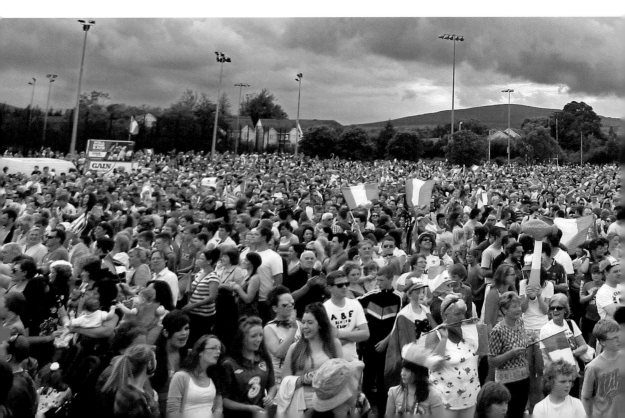

'You could hear a pin drop. Only for Jimmy Magee was so optimistic, the crowd would nearly have been in tears. I've seen her fighting 20 times and I've never seen it this close before,' said Bray's Mayor Mick Glynn.

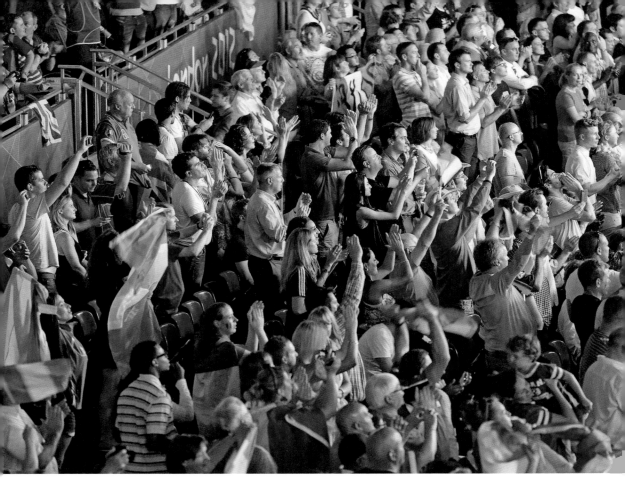

The Irish contingent in the arena celebrate wildly after Katie wins gold at the Olympics. The decibel level was similar to that of a jumbo jet taking off.

'To be boxing in front of so many Irish fans, it is better than I thought it could be. I feel like I am in heaven right now, it is amazing. I feel like I'm boxing at home in Dublin with the support that I'm getting. It's incredible, 10,000 Irish people screaming for me, this is what dreams are made of, and, hopefully, I can make everyone proud in the final,' said Katie.

Her father Peter was equally surprised by the huge turn-out of support for Katie. 'There is meant to be a recession in Ireland. People with their hard-earned cash are coming over here and spending it to support Katie. What can you say? I thought a few mates might come over to support us. It's unbelievable, especially with the state that the country is in ... for people to spend money and come over. It brings tears to your eyes,' he said.

Katie stands proudly for the Irish national anthem with her gold medal during the presentation ceremony at the Olympics. 'She truly deserves this historic and hard-earned victory; it is a just reward for her dedication and commitment over the years,' said President of Ireland Michael D. Higgins.

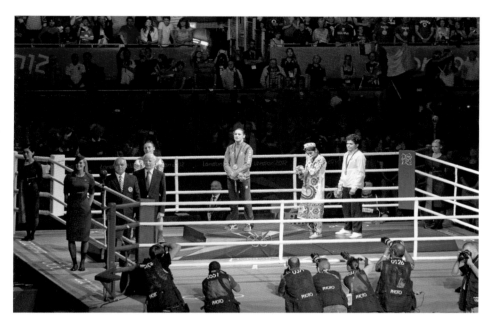

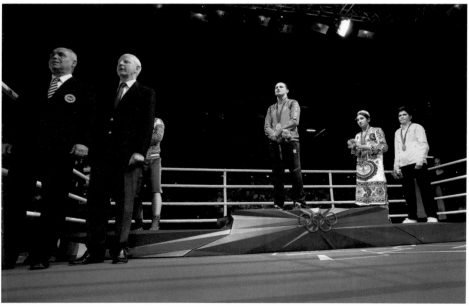

Katie is embraced by Pat Hickey, President of the Olympic Council of Ireland – only the second Irishman ever to be elected to the executive board of the International Olympic Committee – who had the honour of presenting his compatriot with the gold medal. After this triumph, Katie went on to be awarded the Best Women's Boxer Trophy at the London 2012 Olympic Games.

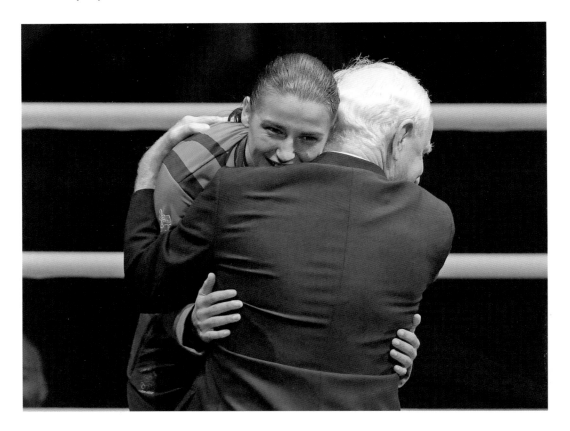

Katie kisses her gold medal when she poses for the press after her historic win. 'I've dreamt of this moment so many times before, I can't believe it,' she said.

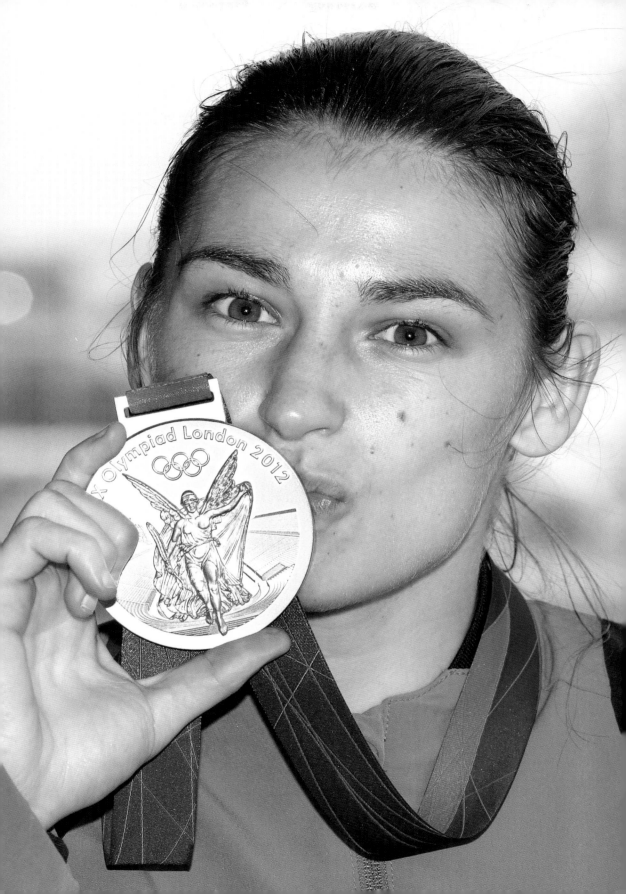

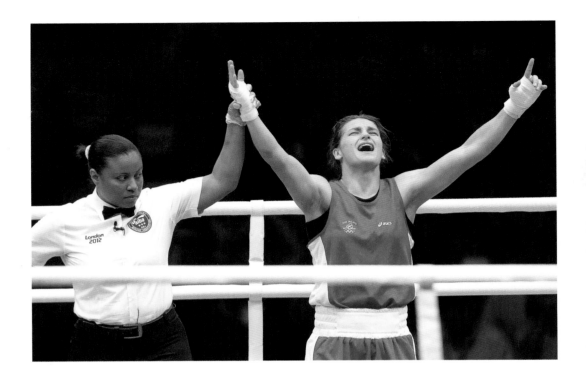

Katie, who pointed up towards the heavens after she won gold, says she always praises God for being her 'shield and her strength'. Her fans would be well used to hearing the born-again Christian frequently speak of God in her post-match interviews. 'I want to thank everyone for all of their prayers over the past week. I had a whole nation praying for me and I felt the presence of God in that stadium,' she said, after winning Olympic gold.

Members of Katie's church – St Mark's Pentecostal Church on Dublin's Pearse Street – passionately rejoice in her gold medal. The church's pastor Sean Mullarkey said: 'Katie normally says, "Thank you Jesus", as that's the focus of her life and that's where her heart is at.'

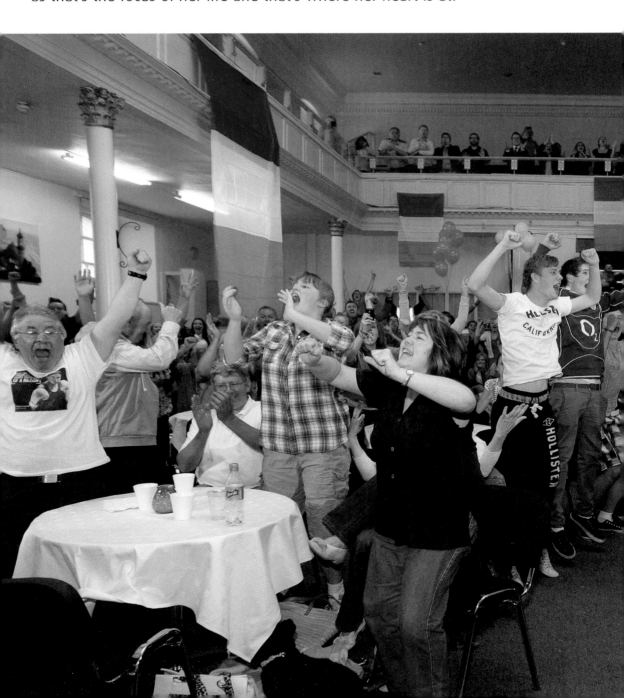

Some children skipping and running with balloons as they soak up the carnival atmosphere at St Mark's Pentecostal Church on the day of Katie's Olympic final bout. Behind them is a poster with the words: 'Praying For You Katie! We Believe!'

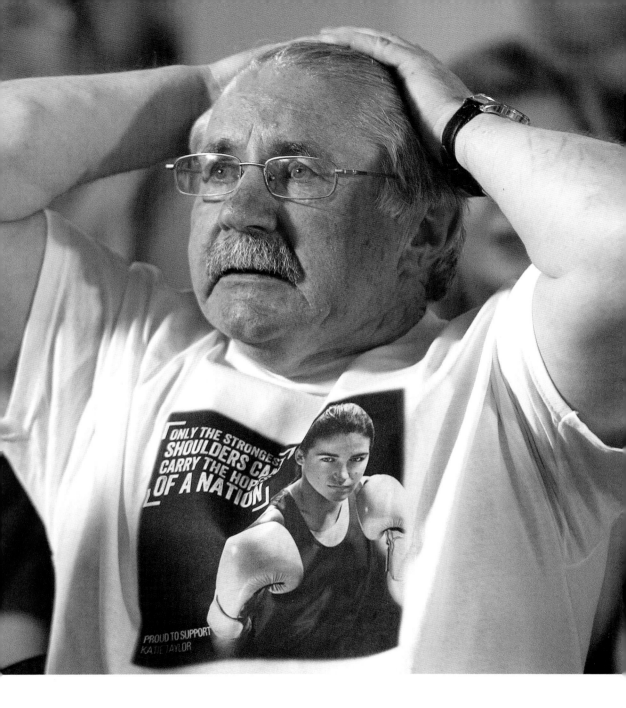

Anxious moments for Martin Hunt, from Clondalkin, as he awaits the judges' verdict after watching the tense Olympic final, in the same church where Katie regularly attends on Sundays with her family.

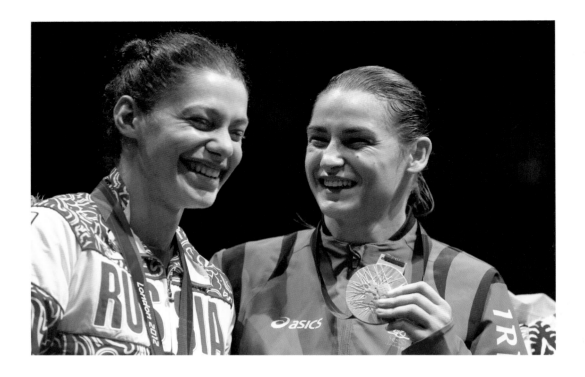

Losing finalist Sofya Ochigava shares a joke with Katie on the podium at the medal presentations. It was possibly the only time that the disgruntled, losing finalist was pictured not sulking. The sourpuss Russian, who had to be cajoled by her corner to congratulate Katie after the fight, even had her arms folded and sulked after she received her silver medal. The sore loser gave some below-the-belt comments to the press when, speaking through a translator, she fumed after the final: 'As usual, they [the judges] tried their best to let the Irish win. The judges, as usual, corrected the scores in her favour, just as they did during the world championships to let Katie win. What can I say now?

'Yes, Katie is a great fighter, but there are some fighters who are better. Like me! The problem for Katie is she is a good fighter but she doesn't box with as much feeling. She doesn't know when she must stand and when she must go. She only knows when she must stand.'

Katie, however, was gracious in victory by emphasising that the final – which was the third time in four meetings that she had defeated her Russian rival – had been a close-fought battle.

Katie went back to the scene of her victory two days later to watch
Westmeath boxer John Joe Nevin in the 56 kg bantamweight final. He
was the bookies' favourite, but, unfortunately, he lost to Great Britain's
Luke Campbell. Katie and her father are pictured sitting beside fellow
Team Ireland boxers Adam Nolan, and Michael Conlan and Paddy Barnes,
who each won a bronze in the light flyweight division.

Ireland won five medals (one gold, one silver and three bronze) at the 2012 Olympics, four of which came from boxing, with the fifth in showjumping. Katie is here with the three other boxers who won medals at London.

Mullingar boxer John Joe Nevin was heartbroken after he lost his
bantamweight final, but did the nation proud by bringing home
a silver medal. Paddy Barnes (light flyweight) and Michael
Conlan (flyweight) – both from Northern Ireland – each won bronze.

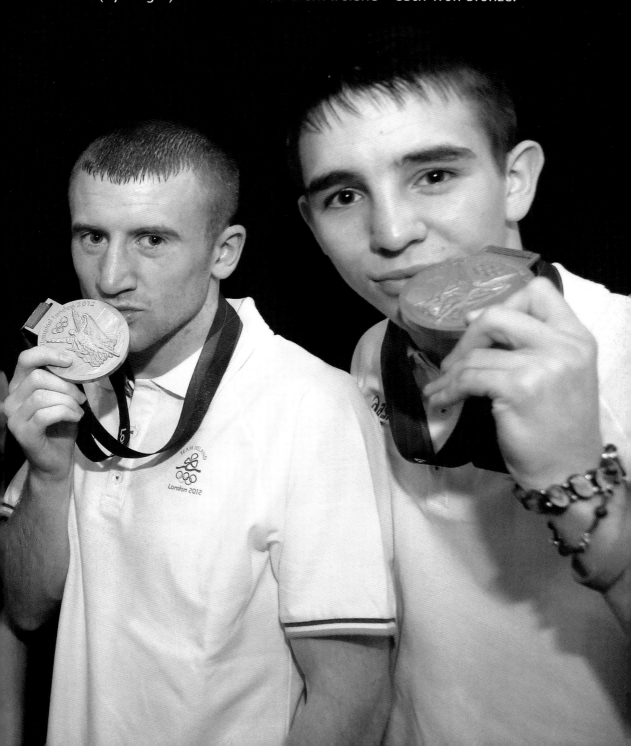

Leinster and Ireland rugby player Rob Kearney was on hand to meet and congratulate Katie after her Olympic victory at a special celebration event at The Big Chill House, King's Cross, London, on 10 August 2012.

Katie with her mother Bridget at a special event to celebrate Katie's historic gold medal in the Olympics at The Big Chill House, King's Cross, London on 10 August 2012. 'We believe that everything that Katie has achieved comes from God, and what she's doing is a gift from him. I always pray with her before every fight for protection and strength. We aren't praying for winning. It's just putting things in his hands and praying that there will be no obstacles in the way and things like that. Even when it comes to negative comments from people, it's important for Katie to know that everything is in God's hands,' says Bridget.

ROUND 14 – WELCOME HOME, KATIE!

It might have been billed as the Team Ireland Homecoming event, but, in truth, the vast majority of fans turned up at Dublin Airport on 13 August 2012 to welcome home their new national treasure, Katie Taylor. People cheered as Katie waved the Irish flag out of the cockpit window as the plane taxied. Katie was first down the steps of the plane and she declared: 'It's been the best two weeks of my life.' She then went into the airport to attend a small reception held for the families of the 66 Irish athletes of Team Ireland. The real party would be held later that day when Katie returned to a rapturous reception in her home town of Bray.

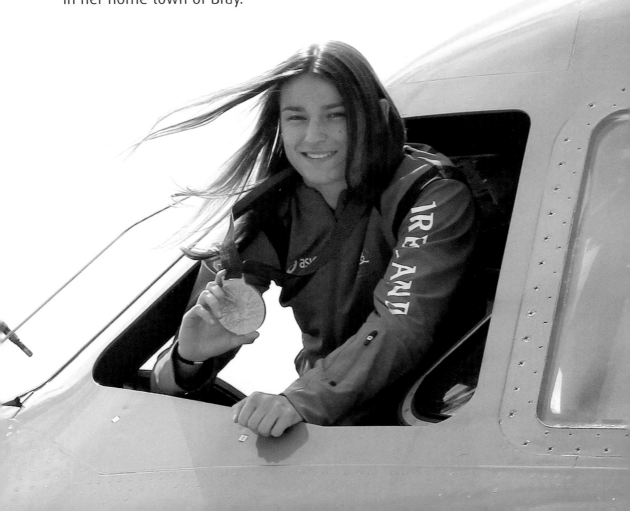

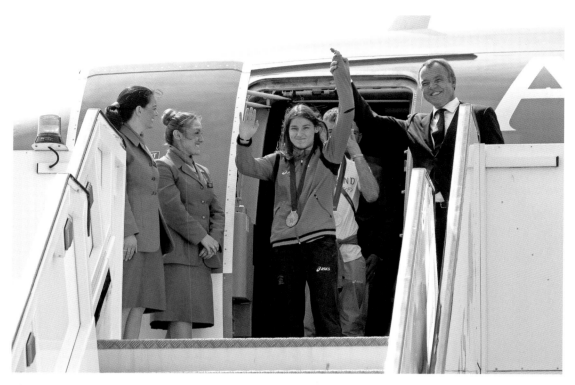

Katie is pictured on her return to Irish soil with Ireland's four other medal winners: John Joe Nevin (silver), Paddy Barnes (bronze), Michael Conlan (bronze) and Cian O'Connor (bronze). Minister of State for Tourism and Sport Michael Ring praised Team Ireland as the 'greatest since 1956', and said that they had 'lifted the souls, minds and hearts of the people in Ireland'.

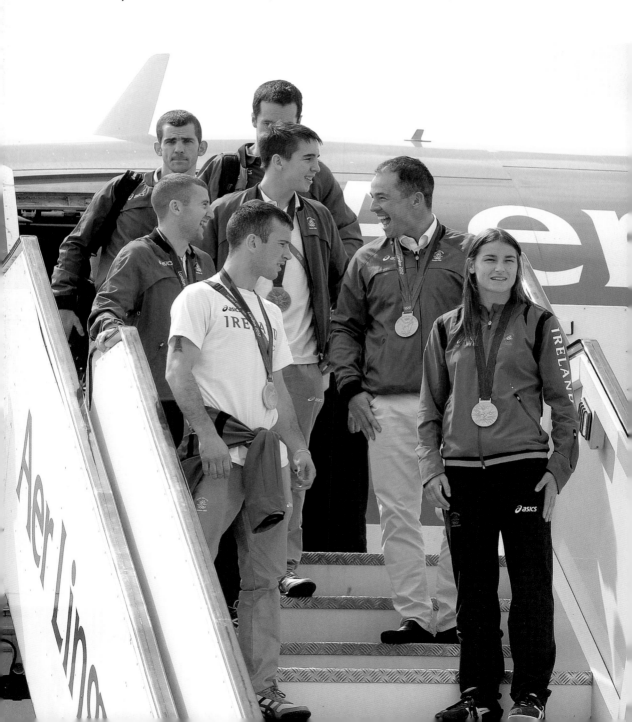

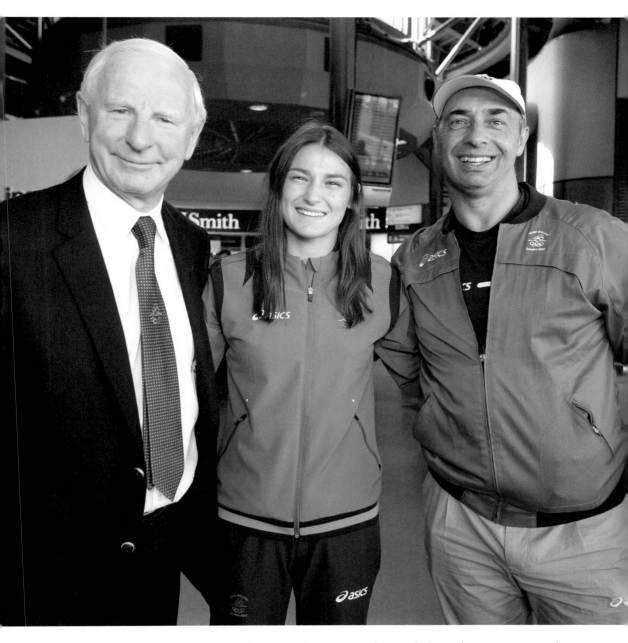

Katie with her father Peter and Pat Hickey, President of the Olympic Council of Ireland, who had presented the champ with her gold medal at the Olympics, at the homecoming celebrations at Dublin Airport.

Katie, along with boxer Adam Nolan, from County Wexford, took an open-top bus home to Bray on 13 August 2012, where they were met by an estimated 20,000 fans who turned up to welcome home their local hero. With the sun shining on a rare warm day in possibly the worst summer in living memory, the revellers enjoyed a carnival atmosphere along the seafront strip, and later a fireworks display. Bray County Council issued a press release before the event, urging fans 'to get out and shout' for Katie's homecoming.

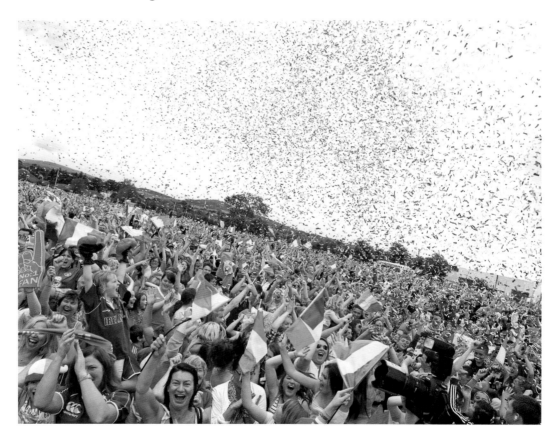

'This medal belongs to everyone here, and without their support I wouldn't be in this situation,' said an emotional Katie, as she looked out in amazement on the sea of green, white and orange at her homecoming event in Bray.

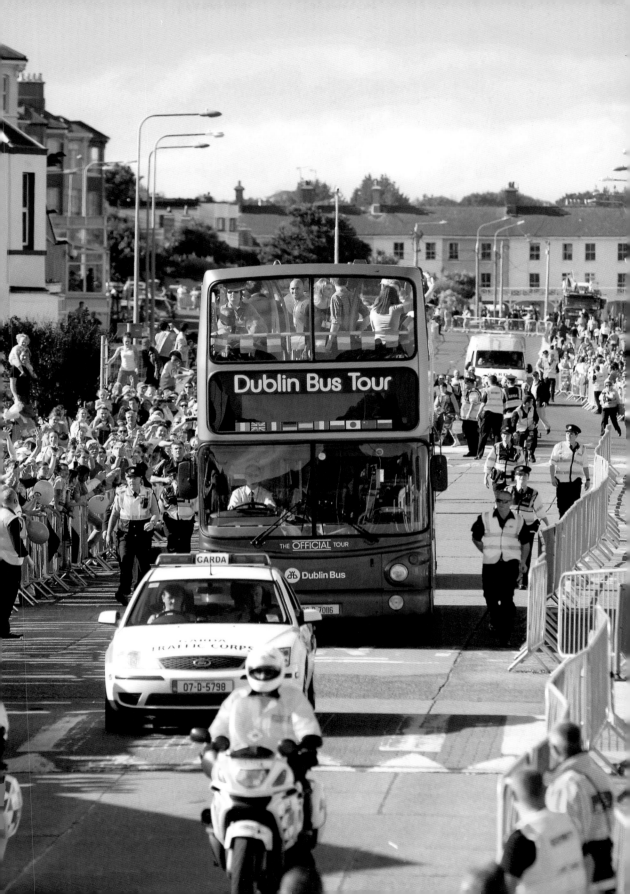

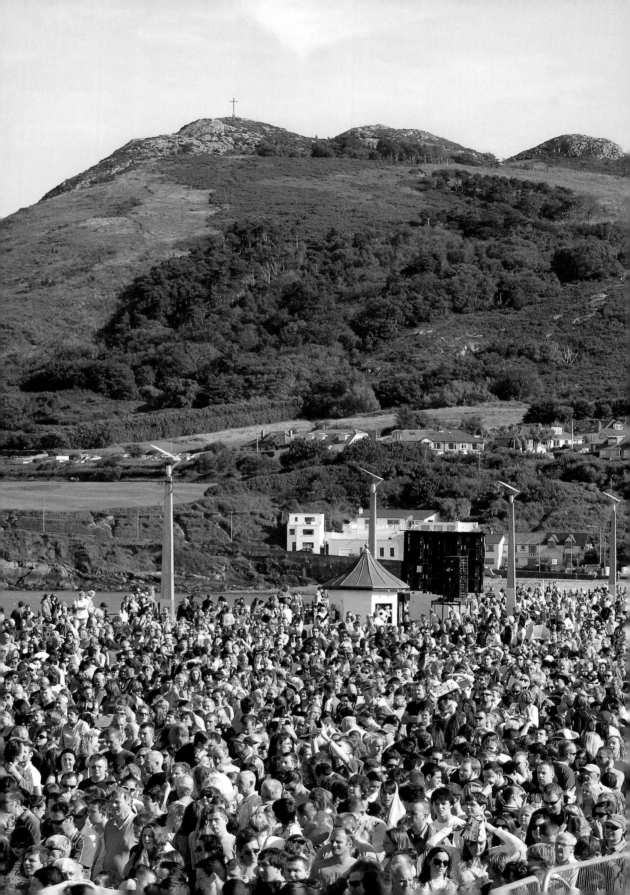

Katie greeting fans at her homecoming reception in Bray. An estimated 20,000 fans turned up to welcome home their local hero on 13 August 2012.

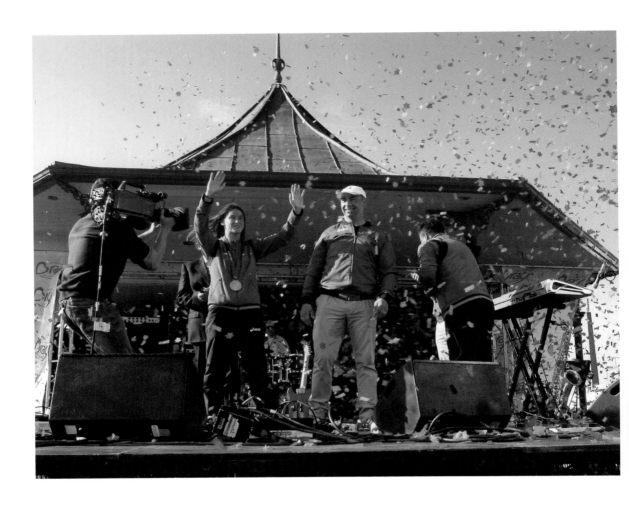

Speaking in front of an estimated 20,000 adoring fans at her homecoming celebrations, Katie told MC Des Cahill: 'I'm just overwhelmed to be honest, this is just incredible. This is unbelievable. I wouldn't be in this situation

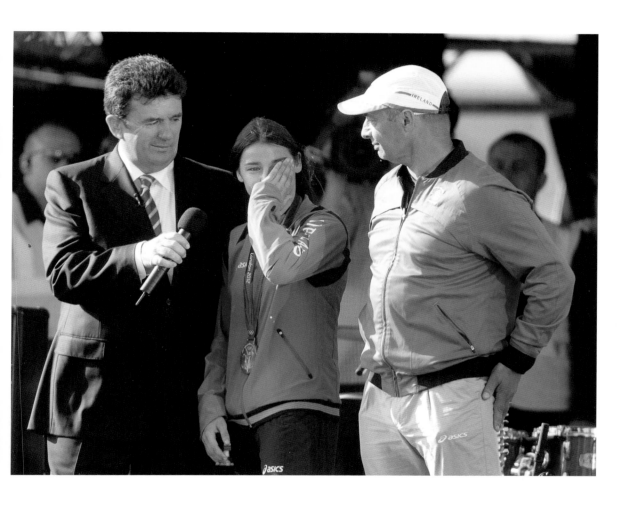

without all the support I've gotten over the last couple of weeks.
The support I got in the ExCel Arena – it blew my mind. Without the
support, I would be nothing.'

Katie, pictured holding up the tricolour, played to the crowd by dancing and shadow-boxing at her emotional homecoming. 'This is unbelievable,' she shouted out to them. MC Des Cahill agreed, telling the crowd: 'I've seen plenty of homecomings. This one is fantastic.' Afterwards, Katie presented the Cathaoirleach of Bray Town Council, Mick Glynn, with a cake, as a

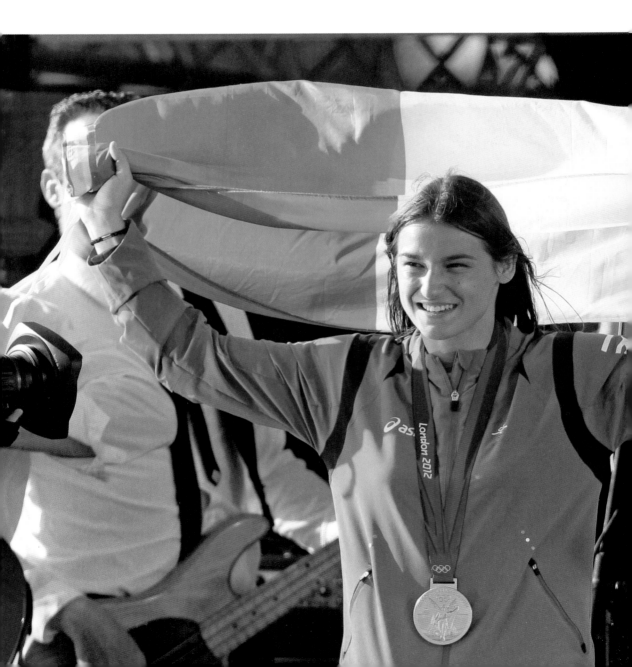

special 'thank you' for the warm reception. After stepping down from the stage, Katie was approached by local reporter Mary Fogarty from her local paper, the *Bray People*, and asked for a comment. It was a soundbite that summed up not only the homecoming event but Katie's own journey to gold:

'It's a privilege to be here. I never expected so many people and it's surpassed my dreams.'

LAST ROUND – PHOTO CREDITS

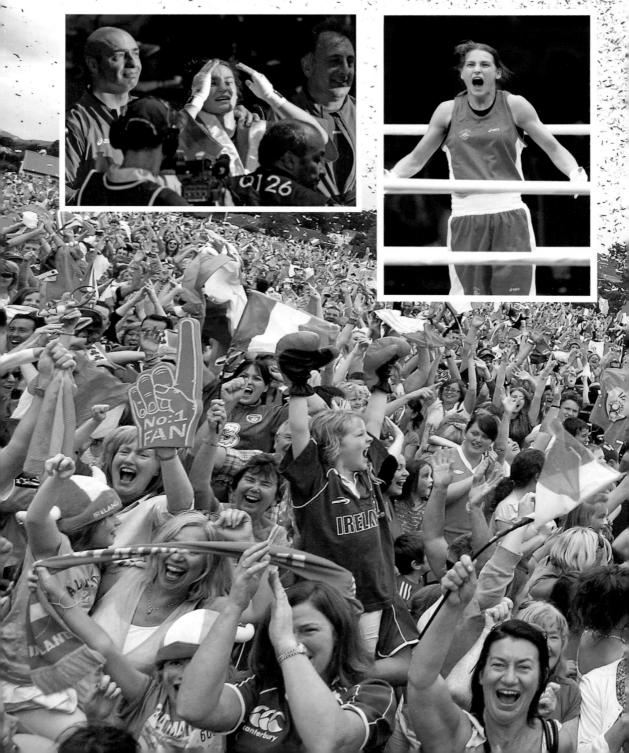